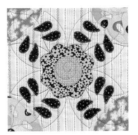

¡Quilt Fiesta!
SURPRISING DESIGNS FROM MEXICAN TILES

Cheryl Lynch

Martingale®
& COMPANY

¡Quilt Fiesta! Surprising Designs from Mexican Tiles
© 2011 by Cheryl Lynch

Martingale ® & C O M P A N Y

That Patchwork Place® is an
imprint of Martingale & Company®.

Martingale & Company
19021 120th Ave. NE, Suite 102
Bothell, WA 98011-9511 USA
www.martingale-pub.com

Credits

President & CEO: Tom Wierzbicki

Editor in Chief: Mary V. Green

Managing Editor: Tina Cook

Technical Editor: Robin Strobel

Copy Editor: Melissa Bryan

Design Director: Stan Green

Production Manager: Regina Girard

Illustrator: Laurel Strand

Cover & Text Designer: Shelly Garrison

Photographer: Brent Kane

Mission Statement

Dedicated to providing quality products
and service to inspire creativity.

Printed in China
16 15 14 13 12 11 8 7 6 5 4 3 2 1

**Library of Congress Cataloging-in-Publication Data
is available upon request.**

ISBN: 978-60468-003-4

47210959 9/11

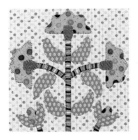

DEDICATION

To my kind and loving husband,
who has supported me through thick and thin.

ACKNOWLEDGMENTS

This book was a result of a trip to Mexico, to whale watch and go deep-sea fishing. But the journey began long before that. I am surrounded by a large group of family members and female friends who have empowered me to make a career out of something that I love—quilting and sharing my quilting knowledge.

My gratitude goes to my family, for always making me feel like I can do anything if I put my mind to it. Stick with me. I couldn't do it without you. And I cherish my constant companion, a little cockapoo named Bailey, who never left my side during the writing of this book.

My heartfelt thanks to my friends Hattie Virgilio, Sue Lafferty, Edith Shooster, and June Wispelwey, who meet me every morning at the park to walk our five miles. They encourage me when I'm discouraged, listen to me when I have lots to say, and love me no matter what.

I have been quilting with Nancy Humphreys longer than with anyone else. She is the best troubleshooter I know and is always available for a consultation, with wise advice.

A big thank you to "Layers—Art in Stitches," my art-quilt group consisting of Jane Hamilton, Christine Kamon, Terry Kramzar, and Kelly Meanix. They have given me inspiration, forced me to grow in my artistic endeavors, provided the best companionship on many quilting journeys, and are always ready to offer an opinion, whether I want it or not.

I can't tell other quilters enough about the benefits of belonging to a quilt guild and being an active participant. The amount of time I've spent volunteering for my guild, "Calico Cutters," has come back to me in support tenfold. The other guild members have encouraged and applauded me, and they have laughed and cried with me. I look forward to seeing all of these women every month.

Cyndi Hershey gave me my first opportunity to be a quilting professional, as a teacher in her quilt shop. She encouraged me to develop my pattern line and is always available as a trusted adviser.

My new friends that I made on our trip to Puebla showed me the generosity and warmth of the Mexican people. Thank you to Kenya Benitez Quiroz, for taking me around the city, sharing her country's culture with me, and continuing to be my pen pal. Thank you to Chef Alonso Hernandez, Isis Moreno Cosme and the staff at Mesones Sacristia, Katia Ramirez Romero at the Uriarte Talavera factory for an after-hours tour, Alfredo at the Talavera de la Luz factory, and Gerardo Vazquez for walking my feet off while showing me every building in Puebla adorned with Talavera tile.

Thank you to Michael Miller, Henry Glass, and Barbara Jones of Quilt Soup for being so generous with their fabric.

My gratitude goes out to everyone at Martingale & Company for giving me this opportunity to be an author and share my creative ideas. Everyone, especially Robin Strobel, has been so wonderful to work with and has made writing this book a joy.

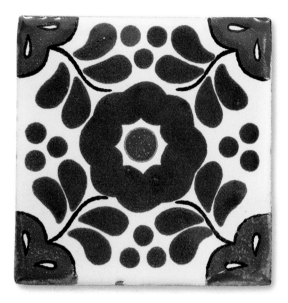

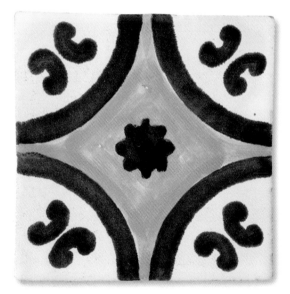
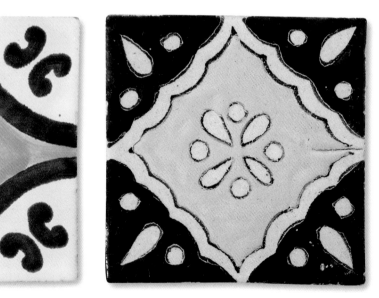

Contents

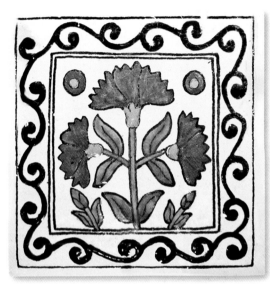

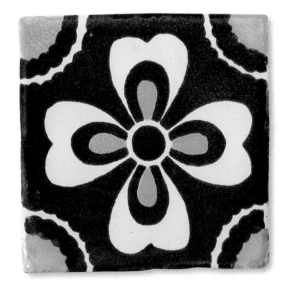

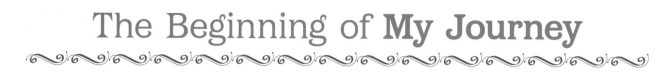

The Beginning of My Journey

Inspiration for quilt designs can be found everywhere, from nature to architecture, fabric, other people's art, and different cultures. When I started designing my own quilts, I began looking around me with a different eye. I started designing quilts based on wooden porch railings, old building details, wrought-iron gates, wallpaper, ocean wave patterns, and even the arrangement of bricks in the sidewalk. You can find ideas everywhere if you let your thoughts wander.

This journey started with a vacation in Cabo San Lucas, Mexico, to go whale watching and marlin fishing. My husband and I went on a day trip to Todos Santos, home of the Hotel California. As we roamed the streets of this quaint little town, I was excited by the variety and uniqueness of Mexican folk art. It was my first exposure, and I found it interesting how their culture has such a huge influence on their crafts.

The hand-painted pottery was just beautiful—everything from dishes and soap dispensers to bathroom sinks. The wares were so plentiful that they were often stacked one upon another upon another. The colors and patterns were numerous and striking. There were lots of tiles with many different designs. I took special note of the tiles with designs in the corners. These reminded me of quilt designs and how much we, as quilters, love the bonus formation of a secondary pattern where four corners come together.

Having been a potter during my college years, I simply had to get a piece of pottery as a souvenir. My husband was a little hesitant when I asked, "Do you think we can bring one of these sinks home with us?" We thought we had nothing to lose, because most of the sinks were not that expensive. I picked out my favorite, and back to the hotel we went. Our plan was to pack it in a carry-on suitcase and transport it by hand all the way home from Mexico through Phoenix, back to Philadelphia.

Upon arriving in Phoenix, we had to go through customs and then through security in the United States. We were a little concerned about what they would see when my suitcase went through the X-ray machine. The TSA agent stopped the belt while viewing my suitcase. He called over another TSA agent and I started to get a little nervous. He said to his colleague, "Hey, Joe, you know how I have told you that people will bring home everything but the kitchen sink? Well, this lady has brought home the kitchen sink!" I'm glad I was able to give them their chuckle for the day.

I did get my sink home safely and in one piece. It is now sitting in its place of honor in my powder room that we remodeled to accommodate it!

My new sink

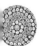

The process for making Talavera pottery is basically the same as it was more than 400 years ago. Each piece is drawn and painted by hand using special glazes.

When I got home I began doing some research into using the tiles I saw in Todos Santos as inspiration for quilt patterns, and that's when I first learned of a city in Mexico called Puebla. Puebla, a colonial city located two hours by bus from Mexico City, is also known as "The City of Tiles." After designing and creating several quilts in this book, I knew I had to go and see this city with my own eyes.

In March 2009, I set off to visit this magical place, accompanied by my faithful companion and personal travel agent, aka my husband. We stayed at Mesones Sacristia, a quaint eight-room hotel that dates back to nineteenth-century Mexico. This establishment is well known for its delicious mole poblano (more on mole later!), and cooking classes are offered there as well. Each morning we learned how to prepare various local dishes and in the afternoon we explored this "City of Tiles."

Most of the tiles produced in Puebla are called Talavera tiles, created using a method of making pottery that was brought to Mexico from Spain in the sixteenth century. Puebla has four certified factories that have

been granted official status by the government, based on their manufacturing ingredients and methods. They are the only manufacturers in Puebla that can call their pottery certified Talavera. This entitles them to put a DO (designation of origin) on the bottom of their product next to the artist's signature.

In the sixteenth century, the people of Puebla decorated their homes and buildings with tile as a sign of wealth. Some of the buildings are completely covered in tile, while others feature facades that combine blue and white tile with red brick. And the tiles are not just limited to building exteriors—tile can be found covering walls, in stairwells, in fountains, and in kitchens. It is quite a sight to see.

This trip to Puebla really got my creative juices flowing. The art, architecture, and crafts were so different from anything I had seen—a fusion of Moorish, Asian, Spanish, and indigenous influences. I was anxious to get home and create quilts inspired by the culture, stories, and heritage.

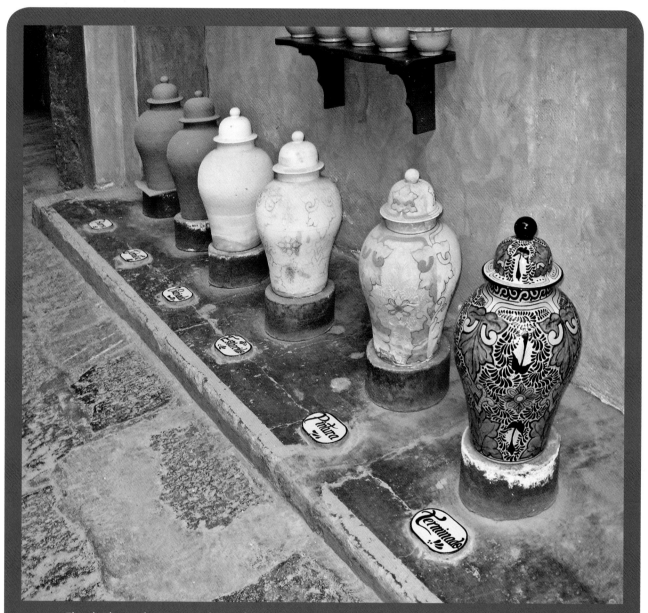

This display at the Uriarte Talavera factory shows a covered urn as it goes through the various steps to becoming a finished piece. First, the clay is mixed, partially dried and worked to the correct consistency, then formed into the desired shape. It is fired at a low temperature, and then dipped in a white underglaze. The patterns are all hand drawn and hand painted, and then the piece is fired at a high temperature for the final time. The entire process takes several weeks to months to complete.

THE BEGINNING OF MY JOURNEY

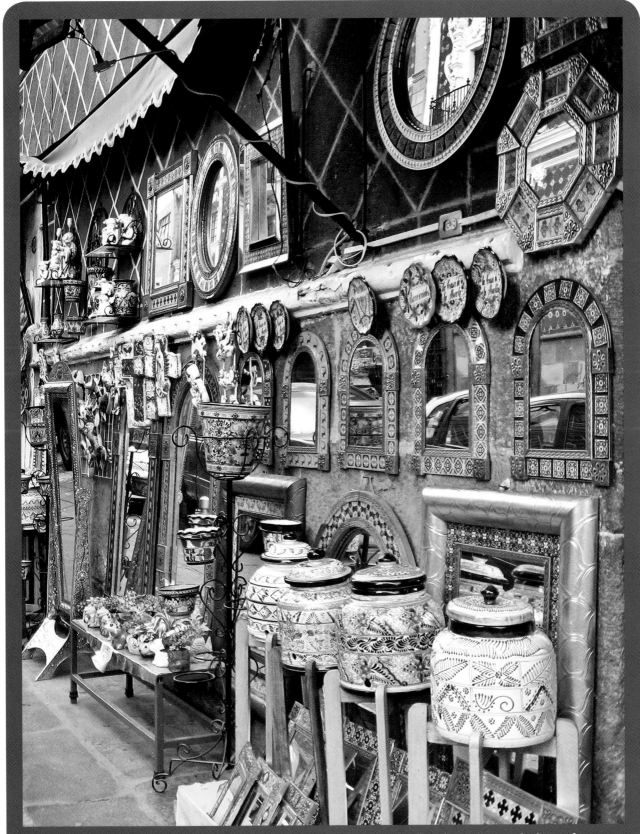

A captivating street in Puebla, named El Parian, is devoted to artists selling their pottery and other crafts. There are designs and pattern possibilities everywhere!

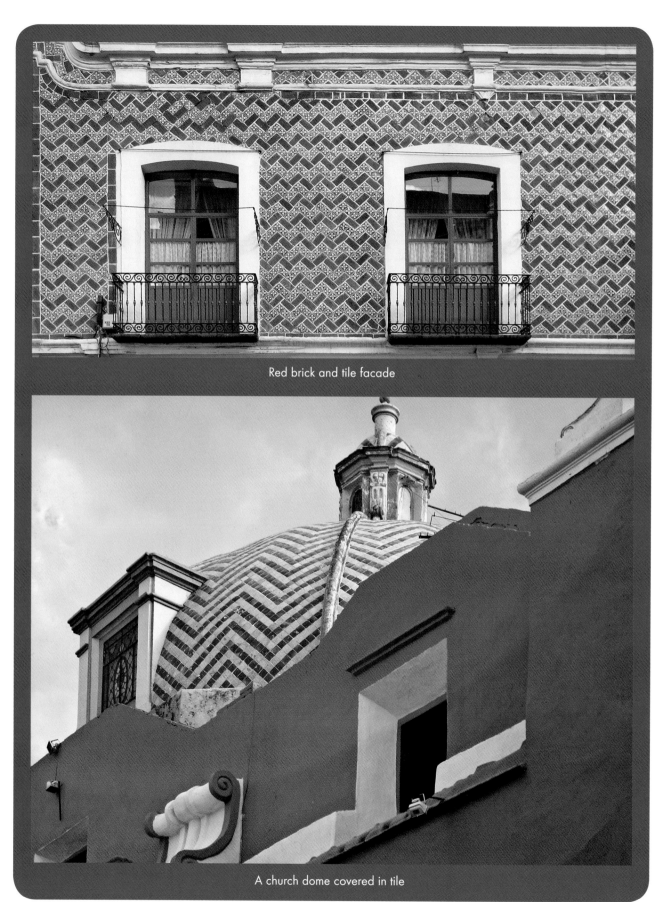

Red brick and tile facade

A church dome covered in tile

THE BEGINNING OF MY JOURNEY

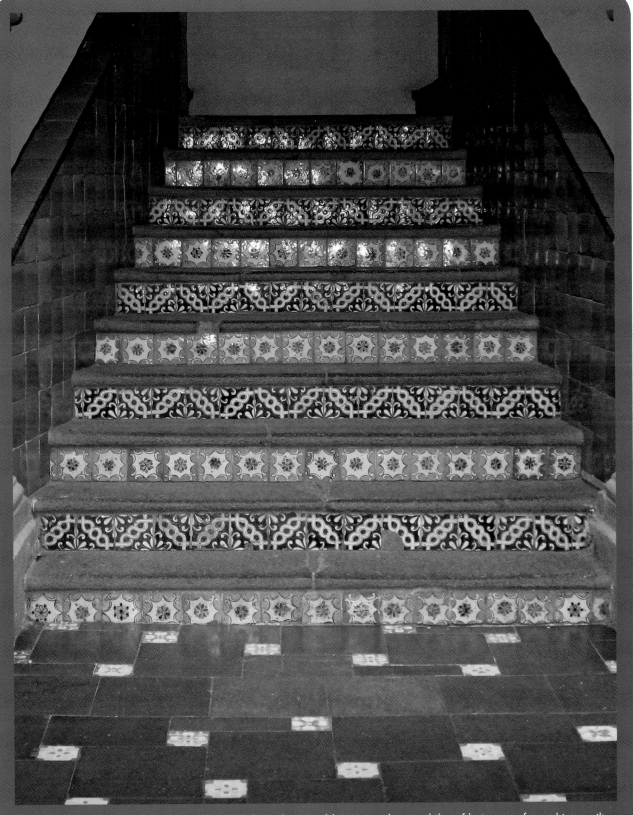

Tiled interior stairwell. The square tiles seen throughout Puebla present the possibility of being transformed into quilt blocks. Patterns from tiles with straight lines can be pieced whereas the other curved designs call for appliqué. The corner patterns and the center patterns can be combined in different ways to form many block variations.

There is a story about the painted tiles on The House of Figures, located right off of the zocalo (main square). The wealthy owner wanted to build a house with a third floor. It would have been the tallest house in Puebla. The city fathers would not allow it, so the owner went directly to the King for authorization. When the King agreed, the owner ridiculed each of the members with painted tiles making fun of them.

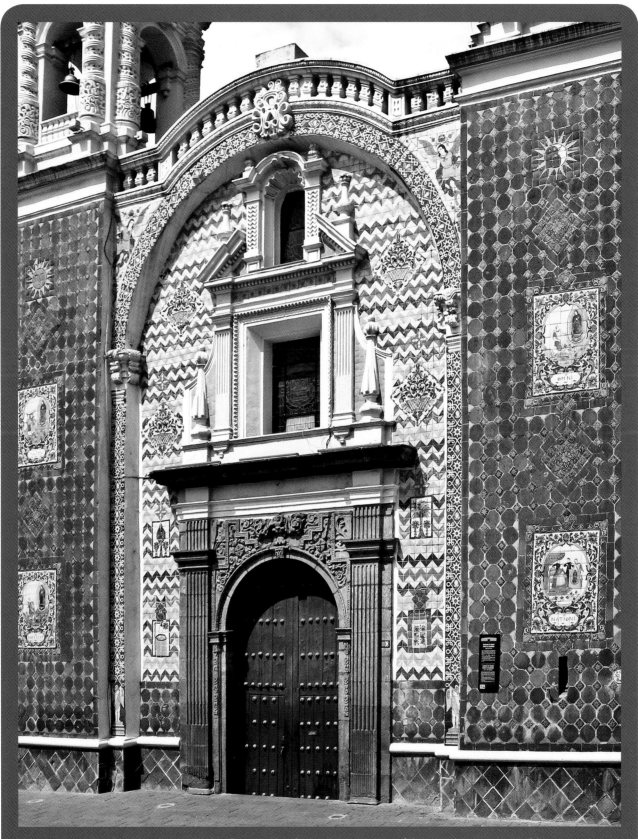

The facade of the Church of Our Lady of Guadalupe is one of the most baroque in Puebla.
The church's construction was started at the end of the seventeenth century, and was completed in 1722.

My scientific background had not prepared me for simply sitting down and freehand drawing new patterns and designs. But it did prepare me to be open to all possibilities. Considering the options for both corner designs and block centers, and how these may interact and lead to numerous quilts, I figured out how to use readily available tools to transfer the designs from the tiles, resize them onto paper, and combine the different corner designs to make secondary patterns. In the section "From Inspiration to Design (page 90)," I share these methods so that you can design your own quilts.

Something very noticeable, and noteworthy, about Mexican folk art is that perfection is not a goal. The pottery is all painted by hand, and often the designs are not exactly symmetrical or always the same size. At the heart of these pieces is simply the joy of creation. We should learn from this. Sometimes trying to achieve perfection prevents us from creating the quilts we want to make—or slows us down and takes the joy out of this wonderful craft of quilting. My philosophy has always been that it is better to *finish* your project than to fret over it, and with each quilt you make, your skill will improve.

So make yourself a batch of pico de gallo. Sit down with some tortilla chips. Decide whether you're going to use one of my patterns or chart your own design territory. And then, let the quilt fiesta begin!

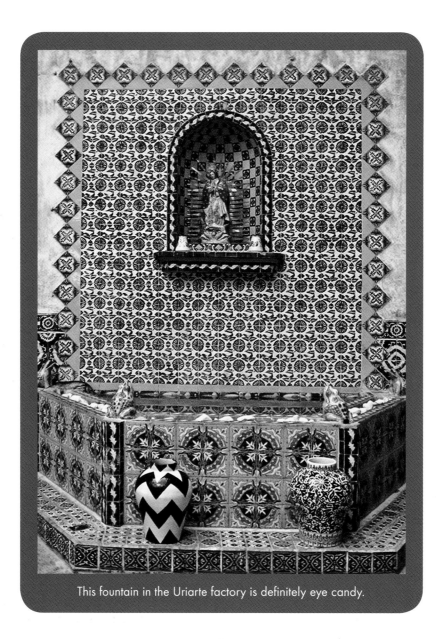

This fountain in the Uriarte factory is definitely eye candy.

Fusible Appliqué

The beauty of fusible appliqué is that there are no edges to turn under. After drawing your patterns onto the paper side of the fusible web, you apply the web to the wrong side of your fabric, cut the shapes, fuse them to the background, and stitch around the edges. It's quick and easy, and it's the method I've used to make all the projects in this book.

Fusible web is actually a very thin sheet of glue that's activated by the heat of an iron. While it comes in a variety of brands and styles, it is usually temporarily bonded to a paper backing or release paper. Fusible web can be purchased off of the bolt, in prepackaged sheets, or as a narrow tape. No single product is perfect for every application, and deciding which to use often comes down to personal preference. Whichever one you choose, follow the directions on the package.

Be sure to use high-quality, prewashed cotton for your projects. On poor grade or loosely woven fabrics, you will end up with frayed edges when you remove the paper backing from the fusible web.

It's extremely important to prewash the fabrics to remove any sizing, and avoid using fabric softener as well. Either of these chemicals will interfere with how well the fusible web adheres to your fabric.

PREPARING THE APPLIQUÉS

Due to the large numbers of identical appliqué pieces required for each project, I recommend creating a plastic template for each shape. A template makes tracing the shape onto the fusible web so much easier—and more accurate.

1. Trace the pattern from the book onto template plastic. Label it and use a sharp pair of scissors to cut out the appliqué template.

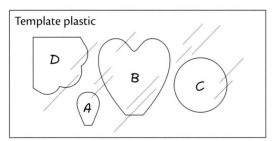

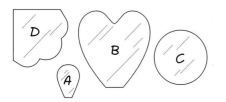

2. Use a pencil to trace around the appropriate template onto the paper side of the fusible web. Pack the pieces as close together as possible to conserve both the fabric and the fusible web.

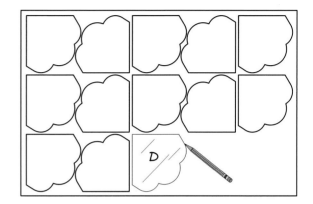

3. Iron the fusible web with the traced pattern pieces onto the wrong side of the fabric. Since they are fused to the wrong side of the fabric, the appliqués are the mirror image of the pattern. Nonsymmetrical patterns in this book have been reversed.

4. Cut out the appliqués with sharp scissors. Remove the paper unless the directions state otherwise. To release stubborn paper, score it with a pin.

FUSING THE APPLIQUÉS

Multiple identical blocks make up each quilt, so accurate placement of the appliqués on the background squares is important.

1. To assure the correct placement of the appliqués, prepare a placement guide, including marked corner guides, using a fine-point permanent marker and clear vinyl or plastic. Any type of clear plastic or acetate will work. It can be the clear vinyl available by the yard in the home-decorating department at your local fabric store, or try clear plastic report covers or cellophane.

one more use for food storage bags

Clear gallon-size food storage bags from the dollar store are usually free of any printing. They are perfect to use as placement guides and then can be reused to store the pattern pieces.

15

2. For extra precision, make crease marks in the background fabric by lightly pressing with your iron horizontally, vertically, and diagonally through the center of the block. Position the clear placement guide on top of the background fabric. Slide the appliqués in place underneath the plastic.

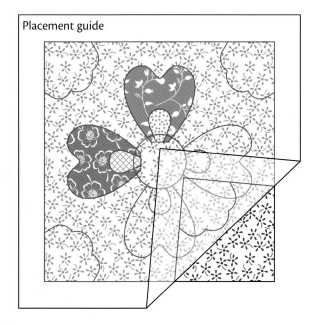

Placement guide

3. If one appliqué is to be positioned completely on top of another, prepare this unit separately before fusing to the background square. Remove the paper from the top piece and fuse to the bottom piece. Do not remove the paper from the bottom piece until after the top one is fused. Remove the paper from the bottom piece, blanket-stitch around the top piece if desired, and fuse the unit to the background.

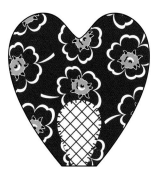

keeping it clean

Lay a scrap piece of fabric or muslin over your ironing-board cover to protect it from extraneous fusible web.

4. Remove the placement guide and press the appliqués in place according to the product's directions.

iron cleaning

To prevent gunk from clogging up your iron, place a Teflon appliqué sheet or parchment paper on top of the block before pressing. If you do get fusible web on your iron, first try removing it with a used dryer sheet on a warm iron or a Mr. Clean Magic Eraser. If that doesn't work, use the never-fail commercial iron cleaner Iron-Off by Dritz.

STITCHING THE APPLIQUÉS

All the fusible appliqués in this book were secured with a machine blanket stitch, except for the "Floral Fiesta" place mats (page 73), that were done by hand. I chose the blanket stitch for its folk-art look, but it has the extra benefit of keeping the edges from fraying and lifting off the background fabric.

Machine Stitching

There are several things that will greatly facilitate machine blanket stitching.

- An open-toe presser foot
- Blanket-stitch option
- Needle-down option
- Knee lift

If your machine does not have a blanket stitch, a narrow zigzag stitch will work.

If you want your thread to disappear against the surface of the appliqué, choose a cotton thread that matches the color of the piece. Using a different-color thread adds another level of interest to the quilt. I chose to use rayon thread for blanket-stitching around the appliqués. Most of the rayon that is readily available is 40-weight. If I can find it, I like to use 30-weight, which is a little thicker and more visible. The sheen of the rayon really accentuates the stitching.

You have several choices for the bobbin thread. The options I have used include a neutral bobbin-weight thread or cotton piecing-weight thread, the same thread that is on the top, or invisible thread. They are all acceptable and it's a matter of personal preference.

For the blanket stitch, set the stitch width and stitch length to the same number. Stitch on a scrap piece of fabric first to adjust the stitch length and width to the desired size. Adjust the tension so that only the bobbin thread is visible on the bottom fabric and only the top thread is visible on the top. You'll most likely need to loosen your top tension and maybe tighten the bottom tension. Then set your machine to stop in the needle-down position if possible and bring the bobbin thread up to the top.

Keep the stitches perpendicular to the edge of the appliqué when stitching along a straight piece.

When stitching a curve or circle, the stitches should still be perpendicular to the edge. To achieve this, visualize the edge as very short line segments. The stitch entering the appliqué fabric should be perpendicular to each segment. That means you'll need to turn your fabric frequently to keep the stitches perpendicular as you go along, which should be done with the needle in the down position. For deep Vs, place a stitch right into the point or valley.

After stitching a few appliqués, thread the thread tails in a hand-sewing needle and bring them to the back side of the block. Tie them in a knot and then run the needle through a few stitches on the back. (This will prevent any stitches from coming undone with use.)

Stitching by Hand

A basic whipstitch was my stitch of choice for the "Floral Fiesta" place mats on page 73. Use a very sharp embroidery needle for easier stitching through the fusible web, especially when you have multiple layers. The eye of the needle should be just large enough to accommodate the thickness of the thread.

Double the thread and knot it. Come up through the appliqué approximately ¼" from the edge (A). Then insert the needle into the background fabric just beyond the edge of the appliqué (B), and come back up inside the appliqué about ¼" from A. Follow the same instructions as for machine appliqué to keep the stitches perpendicular to the edge of the appliqué through points and curves.

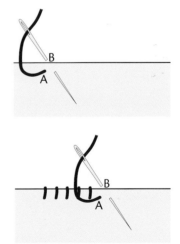

Foundation **Paper Piecing**

Paper piecing involves sewing the fabric to a paper foundation that is removed after the blocks are put together. Paper piecing is the construction method for "Salsa Verde" on page 53 and the blocks behind the appliqué pieces in "Jalapeño Poppers" on page 61. It's a quick and easy method that eliminates tedious cutting, measuring, and precision sewing of irregular shapes and long, pointy pieces. The paper foundation also helps to stabilize bias edges. The unique aspect of this technique is that the block is formed in reverse, with the fabric sewn underneath the paper pattern. Since the blocks for the paper-pieced projects in this book are symmetrical, this reverse imaging is inconsequential.

The paper foundation for the projects in this book needs to be at least 10" x 10", though I prefer to use 11" x 11" because it is always nice to have extra paper in the seam allowance. There are commercial products available or you can use newsprint or tracing paper. The latter two are available in tablets from local chain craft stores. The advantage of newsprint is that it tears off easily. The advantage of tracing paper is that it is transparent, which helps with fabric placement; the disadvantage of tracing paper is that it tends to curl.

PREPARING THE FOUNDATIONS

The first step is to make the foundations upon which to sew. Each block will require one paper foundation. Here is a way to make paper foundations without tracing them all individually.

1. Trace the pattern for the desired project onto the chosen foundation paper, using a light box if necessary. Make sure both the finished block edges and the seam allowance are traced. It is helpful to also transfer the numbers, which indicate sewing order.

2. Cut 10"–11" squares of foundation paper and stack 8 to 10 of them.

3. Place the paper with the traced pattern on top and staple the stack together in four or five places, making sure there are no staples on any seam lines.

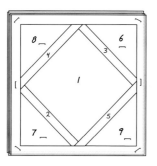

4. Choose the longest stitch length on your sewing machine. I set my machine at 5.

5. Stitch along each of the sewing lines with an unthreaded needle. The perforated lines become your sewing lines.

6. Remove the staples.

CONSTRUCTING THE BLOCKS

The pieces of the block are numbered in the order they are sewn. Once you are comfortable with paper piecing, it is faster to do the block construction in an assembly-line manner.

1. Follow the cutting guide for the chosen project.

2. Position piece 1 on the wrong side of the paper, right side facing out, so that its edges equally overlap the sewing lines on the paper. Hold in place with a couple of straight pins.

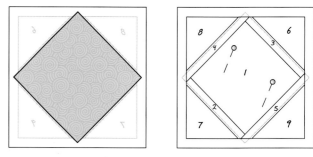

3. Place piece 2 on piece 1, right sides together, aligning the raw edges. Pin if needed.

18

4. With the foundation paper on top, sew on the line between pieces 1 and 2, beginning and ending a few stitches beyond the line.

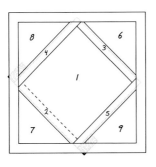

easier foundation paper removal

Shorten your stitch length by about 25% to make the paper removal easier. I decrease my stitch length from 2 to 1.5. Don't go too short, though, or you will find it very difficult to remove the stitches if there is a mistake.

5. Repeat steps 3 and 4, sewing piece 3 to the foundation.

6. Press both pieces outward. Place the block on your cutting mat so that the paper side is up. Fold back the paper along the sewing line and trim the seam allowance and ends of the strips to ¼" if needed.

7. Continue adding the pieces in numerical order until the block is complete.

8. Trim the outside of the block along the ¼" seam allowance so that the unfinished block measures 10" x 10".

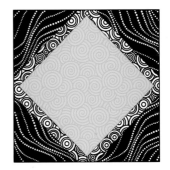

trimming the block

A 10" square ruler is very helpful in trimming the paper-pieced blocks.

9. After the blocks are put together and stabilized with a border, remove the paper foundation from the blocks.

Quilt Construction

All projects in this book use ¼" seam allowances. To sew with a consistent ¼" seam allowance, place a clear plastic ruler on the bed of your sewing machine, with the needle on the ¼" mark. Place a stack of sticky notes along the edge of the ruler. The stack becomes the sewing guide.

CONNECT THE BLOCKS

Have you ever accidentally rotated a block in the wrong direction when sewing blocks together? The following method is easier than it looks and it helps keep all the blocks oriented in the correct direction.

1. After you lay out the quilt, stack the blocks in columns with the blocks in the first row on the top. (You should have as many stacks of blocks as there are columns in the quilt.) Sew the top block in column 1 to the top block in column 2. Do not cut the thread. Continue down the stacks, sewing the blocks in column 1 to the blocks in column 2, one row at a time, without cutting the threads between rows. In the same manner, sewing one row at a time without cutting the threads between rows, sew the blocks in column 3 to those in column 4.

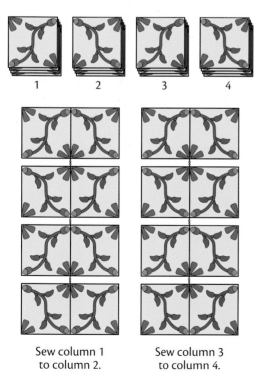

Sew column 2 to column 3.

Sew column 1
to column 2.

Sew column 3
to column 4.

2. Sew the column 2 blocks to the column 3 blocks without cutting the threads between the rows. Repeat until all the columns are attached. Press the seam allowances in the opposite direction from row to row so that they will nestle together when the rows are sewn together.

3. Still leaving the threads between the rows intact, flip row 1 over row 2, right sides together. Sew the rows together, nesting the seams where they meet. Repeat until all the rows are sewn together.

ADDING THE BORDERS

To ensure that the border strips fit the quilt top, it is best to measure the actual width and length of your quilt top before you cut the borders. That way, you can custom fit the borders to your quilt.

For the length of the side border, measure vertically through the middle of the quilt. For the top and bottom border length, measure horizontally through the middle of the quilt.

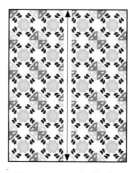

Measure vertically for
side border length.

Measure horizontally for top
and bottom border length.

Do this for both inner and outer borders. Check the project directions for the orientation of the borders—whether they meet each other at a border block corner, end before border block corners, or continue to the edges of the quilt top.

You may need to join fabric strips to have enough length for an inner border or for binding. The best way to do this, to make the seam less obvious, is to join strips with a diagonal seam. Position the two strips of fabric perpendicular to each other, right sides together. Join the strips by sewing across them diagonally as shown. Trim the seam allowance to ¼" and press it open.

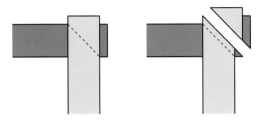

I prefer not to piece my outer borders, as I often find the seams of a pieced outer border to be obvious and distracting. Sometimes this necessitates buying extra fabric, but it's an investment that I don't mind making.

To attach the borders to the quilt top, find the middle of the quilt top and the border. Match the middle and the edges of the border to the middle and the edges of the quilt top. Pin in place and sew.

PIECING THE BACKING

As a general rule, the fabric for the quilt backing should be at least 6" wider and 6" longer than the top. Some long-arm quilters want at least 8" extra.

If you choose to use the yardage recommended in the materials list for your backing, remove the selvages and cut it in half widthwise. With a ¼" seam allowance, sew the pieces together along the long edges and press the seam allowance to one side. Trim any excess.

Another option is to construct the quilt backing from numerous pieces of fabric. This is my preferred method, for several reasons:

- After creating 20 identical blocks, it is a stretching exercise for my brain.

- It is economical and affords me the opportunity to use leftover fabric.

- Structurally, the multiple seams in both horizontal and vertical directions minimize how much the backing can stretch and therefore increases its stability.

- It's an opportunity to showcase a special fabric.

- Because it is quite unexpected. It's a great "WOW!" factor.

To begin piecing the fabric for the back of your quilt, lay out all of your available backing fabric. Look for the largest pieces of fabric. Their length will help you determine if your backing will have a vertical or horizontal orientation. Lay out the rest of the fabric, then sew the pieces into long strips and sew the strips together. Press all seam allowances to one side as you go.

Since "Black Bean Mole" (page 47) is a scrappy quilt, there were many pieces of lots of different fabrics available for use in the quilt back. The fabric remaining from the borders was the central basis for the back. The other scraps were then pieced together in vertical strips and added to either side of the black batik.

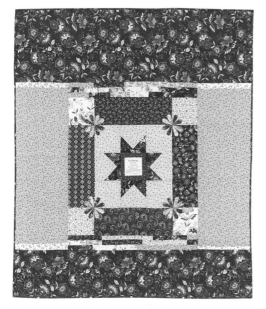

I really got creative with the backing for "Casa Talavera" (page 67). I originally bought a fat quarter collection to design this quilt. To construct the inner and outer borders, I had to purchase yardage. I used only about half the width of the blue border fabric, so the leftovers became an enlarged star and two horizontal strips. I tried to use up as much of the fabric from the fat quarter collection as I could— which led me to the appliqué petals and small joiner strips. This pieced back is really a "WOW!"

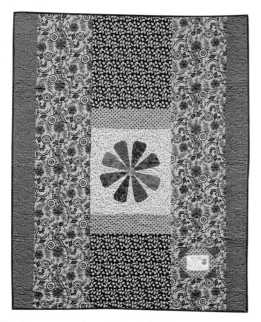

I liked using an enlarged block for the back so much that I did it again for "Frida's Flowers" (page 41). This time the enlarged flower was fused to a large piece of extra fabric. I stitched around it with the blanket stitch and again used the remaining border fabric to add to the sides.

LABELING YOUR QUILT

Almost every teacher and every book tells you that you must document your quilt with a label. You know that it's the right thing to do, but by this point, you just want to finish that quilt. Who has time for a label?

If it's simple enough and doesn't require a whole lot of thought, however, you would do it. I like to hand or machine stitch the label to the backing fabric before the quilt is basted. Adding it to the back before it is quilted makes the label a permanent part of the quilt.

On my labels, I include:

· The name of the quilt

· My name

· My address

· My phone number

· The date it was completed

· The type of batting

· The name of the quilter, if it was not me

I include my address and phone number for identification purposes. This way, if you are going to mail your quilt, whether to a friend or relative or to a quilt show, and it gets misplaced or lost at some point, the finder can locate you. I also include the type of batting. I do this because I like to experiment and try different batts for comparison. The label reminds me what's inside. The label also reminds me when I finished the quilt and who quilted it.

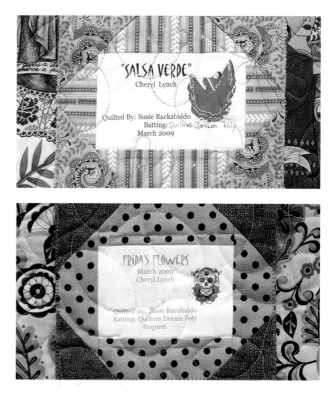

To make label making painless, I came up with a format for all my labels on my computer. I use a word-processing program such as Microsoft Word to design them and treated printable fabric to print on.

Whether you print a label from your computer or make it with a permanent marker, it is fun to add a pretty fabric frame around it.

1. Make a label 3¼" x 5½", being careful all the printing is at least ¼" from the edge.

2. Cut two strips of fabric 2" x 5½" and two strips 2" x 6¼" to border the label. Sew the 2" x 5½" strips to the top and the bottom of the label. Press the seam allowances toward the strips. Sew a 2" x 6¼" strip to each side of the label and press.

3. Cut four squares, 3½" x 3½", of contrasting fabric. Place a square in a corner of the label, right sides together. Sew across the square diagonally as shown. Press the triangle toward the corner. Trim the fabric behind the triangle, leaving a ¼" seam allowance. Repeat for the remaining corners.

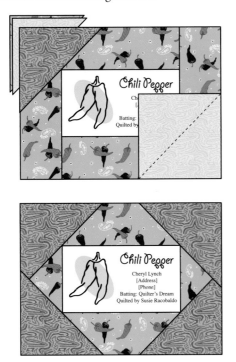

4. Cut a piece of paper-backed fusible web the same size as the label. Fuse it to the back of the label. Trim the label to 6" x 8".

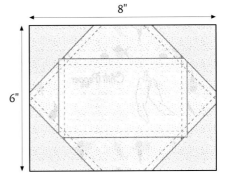

5. Remove the paper backing and fuse the label to the fabric for the back. (I usually place my label in the lower-right corner.)

6. Stitch around the label with the blanket stitch. Now you're documented!

LAYERING AND BASTING THE QUILT

Good options for surfaces to use when basting the quilt include a large table or several tables pushed together, a sheet of plywood, or a table-tennis game table. Hopefully one of these will be big enough so that you don't have to use the floor. Often, your local quilt shop will be happy to loan you their classroom, where you can push a couple of tables together to get a big enough size.

1. Use masking tape to tape the quilt back, wrong side up, to a flat surface. Lay the batting on top. Place the quilt top on top of the batting, right side up, matching the center of both sides of the quilt top with the center of the sides of the backing.

let your batting breathe

If the batting is prepackaged, take it out of the bag the night before you are going to use it, so that it can breathe and decompress.

2. To stabilize the quilt for machine quilting, pin baste the quilt through all of the layers with stainless-steel safety pins, about 4" apart.

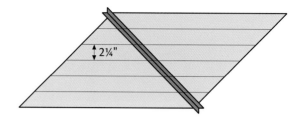

QUILTING

The quilts in this book are not really suitable for hand quilting due to the amount of fusing. For smaller projects, I outline stitch the appliqués and then use free-motion quilting to fill in the background. For the larger quilts, I prefer to send my finished quilt tops to a professional machine quilter.

BINDING

If the quilt is to be used as a wall hanging, bed runner, or table runner, straight-grain binding is recommended. To join the 2¼" strips to obtain the desired length, sew them together end to end in the same manner as for a long border (page 21). Sew straight-grain binding to the quilt the same way as bias binding, beginning with step 5 below.

For any quilt that is going to be used more heavily, such as a lap or bed quilt, I recommend using bias binding, as it's a bit more durable. The 26" square in the materials list with each project is to be used to make continuous bias binding. If you've never used that method, the trick is to keep the bias edges from stretching while you mark, sew, and press. Here's how it works:

1. Fold the square in half diagonally. Place it on the cutting mat, aligning the edges with the mat's edges. Cut through the fold along the 45° line on the mat.

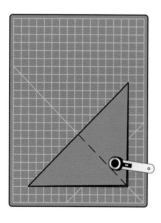

2. Place the two triangles right sides together as shown. Pin and sew the triangles together ¼" from the edge. Press the seam allowance open.

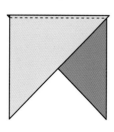

3. With a ruler and a water-soluble marker, draw lines along the longest sides, 2¼" apart.

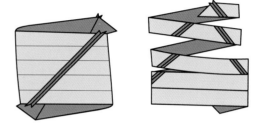

4. Pin the short edges together, matching the lines, offsetting the edges by 2¼". Sew with a ¼" seam. Press the seam allowance open. Use scissors to cut along the marked lines for a continuous binding strip.

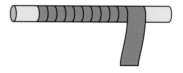

5. Fold the long binding strip in half lengthwise, wrong sides together, and press. If it's not going to be used right away, the binding can be wrapped on the cardboard core of a paper-towel roll and stored until needed.

6. Trim the quilt, squaring up the corners and straightening the edges.

7. Start in the middle of one side of the quilt and align the raw edge of the binding with the edge of the quilt. Leaving a 6" tail of binding unsewn, stitch using a walking foot and a very generous ¼" seam allowance. Stop sewing ¼" from the corner of the

quilt, leaving the needle in the down position. Stitch from that point, at a 45° angle off the corner of the quilt. Cut the thread.

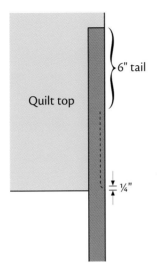

8. Turn the quilt to prepare the next side for sewing. Fold up the binding at a 90° angle.

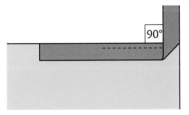

9. Fold the binding down, aligning the raw edges and aligning the fold with the top edge of the quilt. Start sewing from the top edge of the quilt.

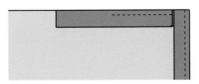

10. Continue sewing around the quilt, turning the corners in the same manner. Stop sewing about 10" from where you started. Remove the quilt from the machine. Overlap the binding tails and trim the ends so that there is a 2¼" overlap.

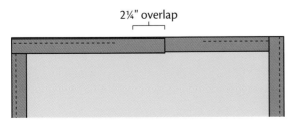

11. Unfold the binding and place the ends, right sides together, at a right angle. Stitch diagonally as shown. Trim the seam allowance to ¼". Press open.

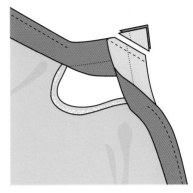

12. Press the binding in half and put it in place along the quilt top. Continue sewing the binding to the quilt top, overlapping the beginning by a couple of stitches.

13. Turn the binding to the back and hand stitch in place.

ADDING BUTTONS

If using buttons, attach them with embroidery floss. Tie them on with a square knot: "right over left, then left over right." Trim ends. To secure, add a drop of Fray Check to the knot.

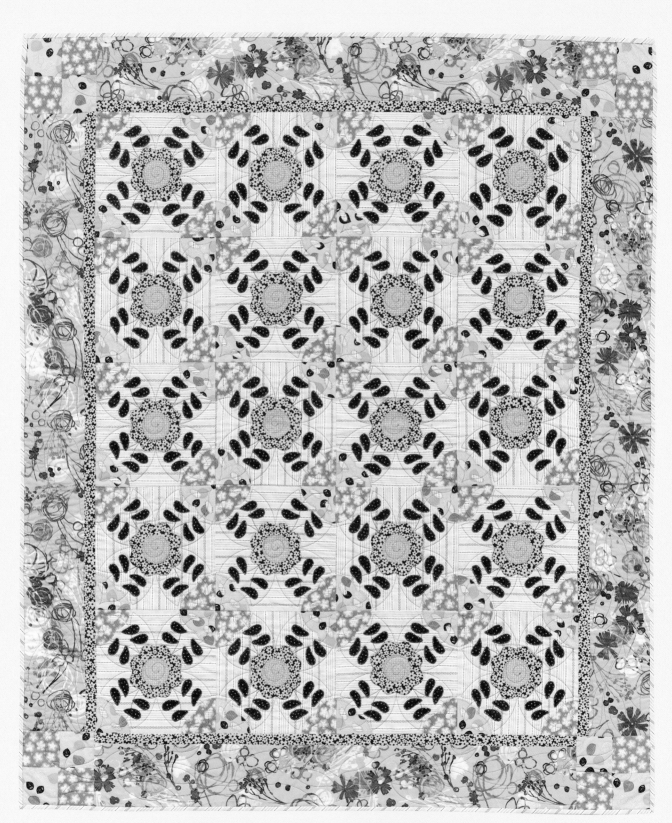

Finished quilt: 51" x 60½" • Finished blocks: 9½" x 9½"
Designed and made by Cheryl Lynch; machine quilted by Susie Racobaldo

Hacienda

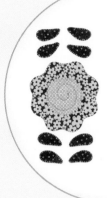

The hacienda, or homestead, is the basis of home life in Mexico. Girls are closely watched and guarded by the family until marriage, and children of all ages remain under their family's roof until they are wed. The single people that I met on my trip to Puebla still live with their parents and other relatives. A wonderful, vivacious 27-year-old woman, who is a successful attorney, still lives at home, and Gerardo, our 37-year-old tour guide, lives at home with his three other single brothers. He was shocked that we were on vacation without our two grown single sons.

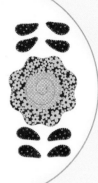

MATERIALS

Yardage is based on 42"-wide fabric.

2⅓ yards of striped fabric for block backgrounds and binding*

1½ yards of multicolored floral for outer border

⅔ yard of blue-and-brown floral for center flowers and inner border

⅝ yard of teal floral for corner flowers and border four-patch

⅝ yard of green leaf print for corner flowers and border four-patch

½ yard of brown print for petals

Fat eighth (9" x 21") of green checked fabric for flower center circles

3⅛ yards of backing

56" x 66" piece of batting

5¼ yards of 17"-wide paper-backed fusible web

If the fabric has less than 40" usable width after washing and putting on grain, you'll need 3 yards.

CUTTING

Cut all pieces across the width (crosswise grain) of the fabric unless otherwise noted. When the strip length is given as 42", simply cut from selvage to selvage across the full width of fabric.

From the striped fabric, cut:

5 strips, 10" x 42"; crosscut into 20 squares, 10" x 10"

1 square, 26" x 26"

From the blue-and-brown floral, cut:
5 strips, 1½" x 42"

From the green leaf print, cut:
1 strip, 3½" x 28"; crosscut into 8 squares, 3½" x 3½"

From the teal floral, cut:
1 strip, 3½" x 28"; crosscut into 8 squares, 3½" x 3½"

From the multicolored floral for outer border, cut along the *lengthwise* grain:

2 strips, 5½" x 50"

2 strips, 5½" x 40½"

APPLIQUÉ PIECES

Use the patterns on page 31 to create the appliqué pieces, referring to "Preparing the Appliqués" on page 15 as needed.

From the blue-and-brown floral, make:
20 of flower A

From the green checked fabric, make:
20 of circle B

From the brown print, make:
160 of petal C

160 of petal D

From the green leaf print, make:
40 of corner flower E

From the teal floral, make:
40 of corner flower E

design decisions

This is the Mexican tile that inspired this book. I saw this tile, and a lightbulb went on in my head. I envisioned the amazing secondary design that these corners would form as four of them came together. To make an interesting background, I chose a striped fabric and rotated the direction of the stripes from block to block. For variety, I used two different fabrics for the corner flowers.

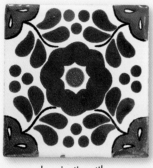

Inspiration tile

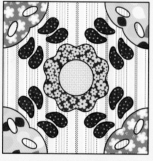

Quilt block

ASSEMBLING THE APPLIQUÉ BLOCKS

Refer to "Fusible Appliqué" on page 15 for details as needed.

1. Remove the paper backing from only the circle B pieces. Place a circle B piece in the center of each flower A, and fuse.

2. Remove the paper backing from the flower A pieces. Blanket-stitch around each circle B.

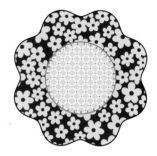

3. Position all of the prepared appliqué pieces on the background blocks using the pattern on page 31 for placement. If a striped fabric is being used for the background of the block, rotate the fabric 90° so that the stripes run vertically in half the blocks and horizontally in the other half before positioning the fusible appliqués. Fuse, and then stitch around the pieces.

ASSEMBLING THE QUILT TOP

Refer to "Quilt Construction" on page 20 for details if needed.

1. Referring to the diagram on the facing page, lay out the center of the quilt top with four blocks across and five blocks down, alternating the direction of the stripes as shown. Sew the blocks into rows and then

sew the rows together. Press the seam allowances in opposite directions from row to row.

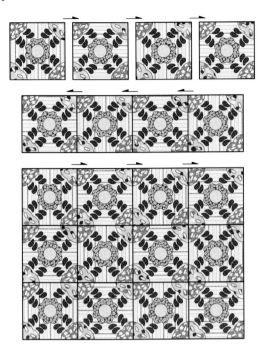

2. Prepare each of the four-patch units for the outer border by sewing together two teal floral and two green leaf 3½" x 3½" squares as shown. Make four.

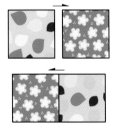 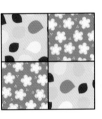

Make 4.

3. Measure through the center of the quilt top vertically to obtain the correct length for both the inner and outer side borders. Stitch together the 1½" strips of blue-and-brown floral, and then cut two pieces to this measurement for the side inner borders. Trim the 5½" x 50" floral strips to this measurement also. Stitch the inner borders to the outer borders and sew to the sides of the quilt top. Press.

4. Before attaching the side borders, measure through the center of the quilt top horizontally to obtain the correct measurement for both the inner and outer top and bottom borders. Trim the blue-and-brown floral strip and 5½" x 40½" floral strips to this measurement. Stitch the inner borders to the outer borders.

5. Attach a four-patch unit from step 2 to each end of the top and bottom borders, orienting them so that a green square is at the outer corners.

6. Attach the top and bottom borders to the quilt top. Press.

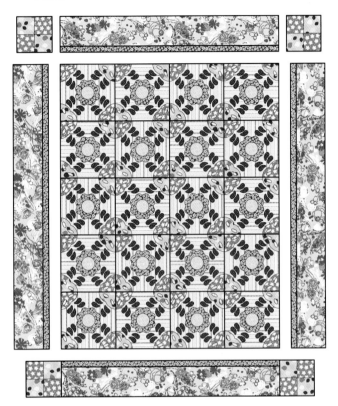

Quilt layout

FINISHING THE QUILT

1. Prepare a 55" x 65" backing by either creatively piecing one or using the fabric listed in the materials list. If using the listed yardage, remove the selvages and cut it in half crosswise. Sew together along the long edges and press the seam allowance to one side. Trim the excess.

2. Prepare a label and sew it to the quilt back.

3. Layer the quilt top, batting, and backing; baste.

4. Decide on a quilting design and mark the quilt if necessary. The quilt shown on page 26 was professionally quilted with an allover flower design centered on each block.

5. Use the 26" x 26" square of striped fabric to bind with 2¼" bias binding. (See "Binding" on page 24.)

This alternative quilt was created using the same colors as the inspiration tile shown on page 28. The fabric prints give it texture and dimension.

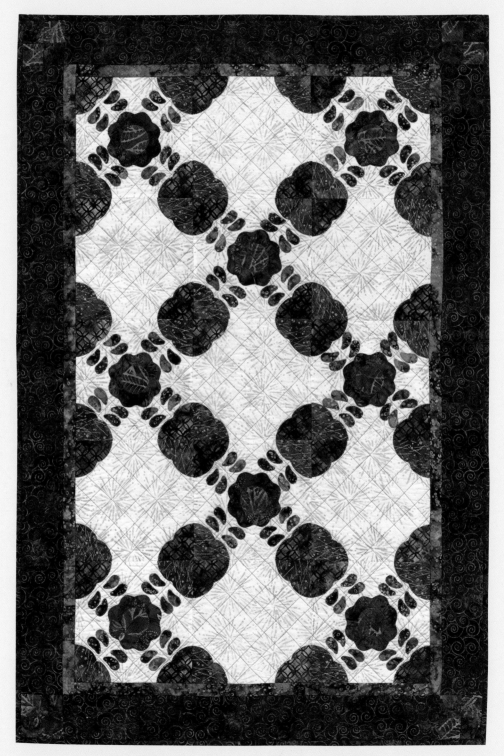

Made by Cheryl Lynch; quilted by Susie Racobaldo

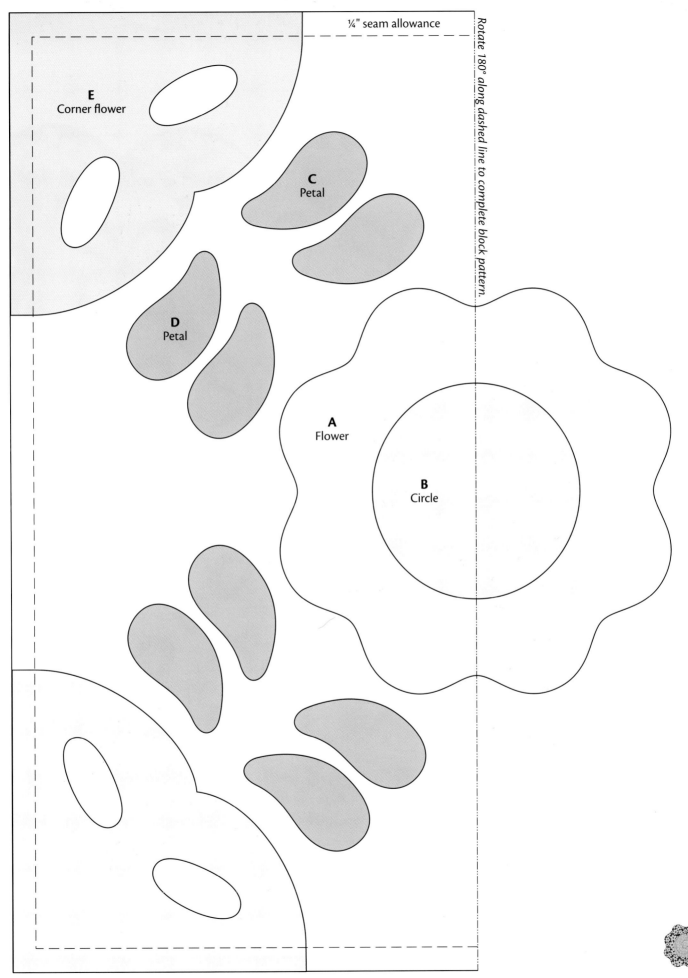

Rotate 180° along dashed line to complete block pattern.

E
Corner flower

C
Petal

D
Petal

A
Flower

B
Circle

Finished quilt: 48" x 48" • Finished blocks: 9½" x 9½"
Designed, made, and machine quilted by Cheryl Lynch

Puebla Posies

Puebla, the fourth-largest city in Mexico, is a two-hour drive from Mexico City. Founded in 1531, it has a colonial downtown with an amazing zocalo, or town square. Surrounded by historic buildings, this plaza has a cathedral on one side, City Hall on another, lots of restaurants and sidewalk cafés, plus trees, gardens, and benches that provide the perfect setting for people-watching. There are even performers and vendors selling balloons, food, and souvenirs. But the best thing about Puebla is that it lives up to its reputation as "The City of Tiles." It's truly eye candy with building facades, walkways, stairwells, fountains, and courtyards covered with Talavera tiles.

MATERIALS

Yardage is based on 42"-wide fabric.

1½ yards of brown floral for outer border

1⅓ yards of pink-and-white print for block backgrounds*

⅞ yard of brown striped fabric for bias binding

⅔ yard of brown polka-dot fabric for outer petals

¼ yard of pink striped fabric for inner border and outer circles

Fat quarter (18" x 21") of pink polka-dot fabric for inner petals

⅜ yard of brown fabric for inner circles and corner triangles

3 yards of backing

53" x 53" piece of batting

2½ yards of 17"-wide paper-backed fusible web

38 yards of ⅜" pink rickrack

9 buttons, ½" diameter

Brown embroidery floss

Freezer paper

10" dinner plate or 10" circular template

**If the fabric is less than 40" wide after washing and putting on grain, you'll need 2 yards.*

CUTTING

Cut all pieces across the width (crosswise grain) of the fabric unless otherwise noted. Whe the strip length is given as 42", simply cut from selvage to selvage across the full width of fabric.

From the pink-and-white print, cut:
4 strips, 10" x 42"; crosscut into 16 squares, 10" x 10"

From the brown fabric, cut:
7 strips, 2" x 21"; crosscut into 64 squares, 2" x 2"

From the pink striped fabric, cut:
4 strips, 1¼" x 42"

From the brown floral, cut along the *lengthwise* grain:
2 strips, 5" x 42"
2 strips, 5" x 51"

From the brown striped fabric, cut:
1 square, 26" x 26"

From the rickrack, cut:
64 pieces, 8" long
64 pieces, 11" long

When I started to design this quilt, I had just purchased yards and yards of rickrack on a field trip to the garment district in New York City. I saw this tile and knew that rickrack around the petals would enhance the whimsy and the Mexican feeling of this quilt. The scalloped border was just the perfect finishing touch.

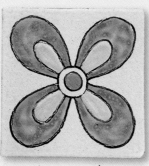

Inspiration tile

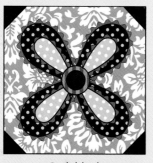

Quilt block

APPLIQUÉ PIECES

Use the patterns on page 39 to create the appliqué pieces, referring to "Preparing the Appliqués" on page 15 as needed.

From the pink polka-dot fabric, make:
64 of inner petal A

From the brown polka-dot fabric, make:
64 of outer petal B

From the brown fabric, make:
16 of inner circle C

From the pink striped fabric, make:
16 of outer circle D

ASSEMBLING THE APPLIQUÉ BLOCKS

Refer to "Fusible Appliqué" on page 15 for details as needed.

1. Remove the paper backing from only the inner petal A pieces. Using the edge of an iron or one of the specialty small irons, fuse an 8" length of rickrack to the wrong side of each petal. Trim the rickrack even with the bottom edge of the petal.

2. Fuse an inner petal A to each outer petal B, matching the bottom edges. Remove the paper backing from the outer petal B. Stitch around the inner petal with a blanket stitch.

3. Fuse an 11" length of rickrack to the wrong side of each outer petal B. Trim the ends of the rickrack so that they extend about ¼" beyond the base.

4. Fuse the petal units to the pink-and-white 10" background squares using the pattern on page 39 for placement. Blanket-stitch around the brown outer petals.

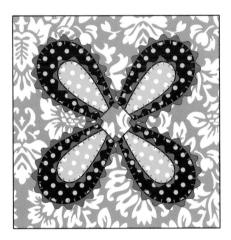

5. Remove the paper backing from the 16 inner circle C pieces. Fuse one to the center of each outer circle D piece.

6. Remove the paper backing from the outer circle D pieces. Blanket-stitch around the inner circles.

7. Fuse a circle unit to the center of each block. Blanket-stitch around the outer circles.

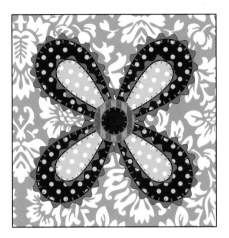

8. Mark a diagonal line on the wrong side of a brown 2" square. Place it in one corner of a block, right sides together. Straight stitch on the marked line.

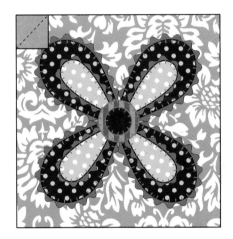

9. Fold the square along the stitching line and press toward the corner. Trim the two layers behind the resulting triangle, leaving a ¼" seam allowance.

10. Repeat steps 8 and 9 for each corner in all the blocks.

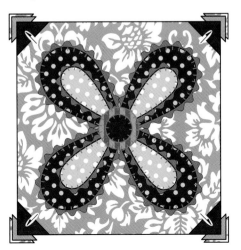

ASSEMBLING THE QUILT TOP

Refer to "Quilt Construction" on page 20 for details if needed.

1. Referring to the quilt layout diagram below, lay out the center of the quilt top with four blocks across and four blocks down, matching the brown corner triangles. Sew the blocks into rows, and then sew the rows together. Press the seam allowances in opposite directions from row to row.

2. To add the side inner borders, measure through the center of the quilt top vertically to determine its length and cut two of the 1¼" pink striped strips to this measurement. Attach to the sides. Press.

3. Repeat step 2 to add the top and bottom inner borders, measuring horizontally to determine the width of the quilt.

4. Repeat steps 2 and 3 to add the 5" brown floral outer borders to the quilt, attaching the side strips first. Press.

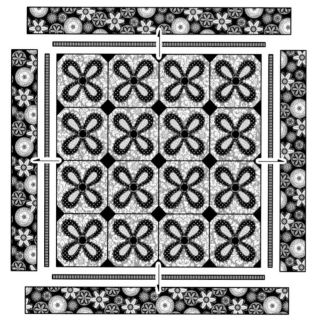

Quilt layout

FINISHING THE QUILT

1. Prepare a 52" x 52" backing by either creatively piecing one or using the fabric listed in the materials list. If using the listed yardage, remove the selvages and cut it in half crosswise. Sew together along the long edges and press the seam allowance to one side. Trim the excess.

2. Prepare a label and sew it to the quilt back.

3. Layer the quilt top, batting, and backing; baste.

4. Decide on a quilting design and mark the quilt if necessary. The quilt shown on page 32 was machine quilted using pink thread in a pattern that echoes the petals.

CREATING THE SCALLOPED EDGE

1. Cut four strips of freezer paper, 4¾" x 49". Press them with the shiny, waxy side against the right side of the outer borders. Find the center of each border length and draw a line.

2. Using either a 10" circular acrylic template or a 10" dinner plate, center your circle with the marked line, ½" from the raw edge of the border. Trace the arc of the circle.

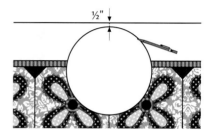

3. Continue tracing on either side of this arc, centering the circle with the seams between the blocks.

4. Continue marking the arcs around the quilt's border. The arcs in the corners will not be perfect, but don't worry—you can smooth them out freehand to make them fit.

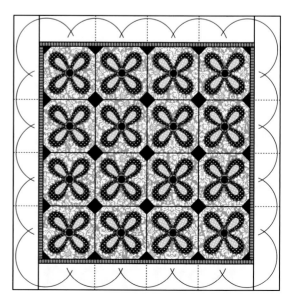

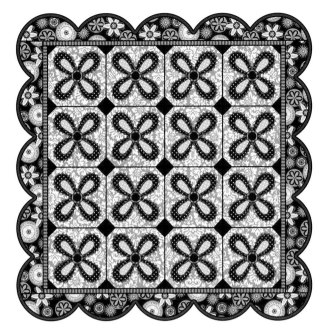

5. Using a walking foot and a contrasting-color thread, machine baste on the marked lines, sewing through all the layers and pivoting where the arcs cross. Baste all the way around the quilt, and then remove the freezer paper. The basting line should be visible.

6. Prepare the bias binding from the brown striped fabric. (To successfully bind a scalloped edge, you must use bias binding. See "Binding" on page 24.) Starting on the outer arc of one of the scallops, attach the binding to the quilt top, aligning the raw edge of the binding with the basting line. Ease the binding in as you pivot in the valleys and go around the quilt corners.

7. Join the ends of the binding. Take a deep breath and trim away the excess fabric and batting even with the raw edge of the binding.

8. Bring the binding to the back of the quilt and hand stitch.

9. Using embroidery floss, tie a button in the center of each of the nine brown squares formed where the blocks come together.

By eliminating the rickrack, using sashing instead of corner triangles, and piecing the border, you can simplify the construction of "Puebla Posies" without skimping on charm.

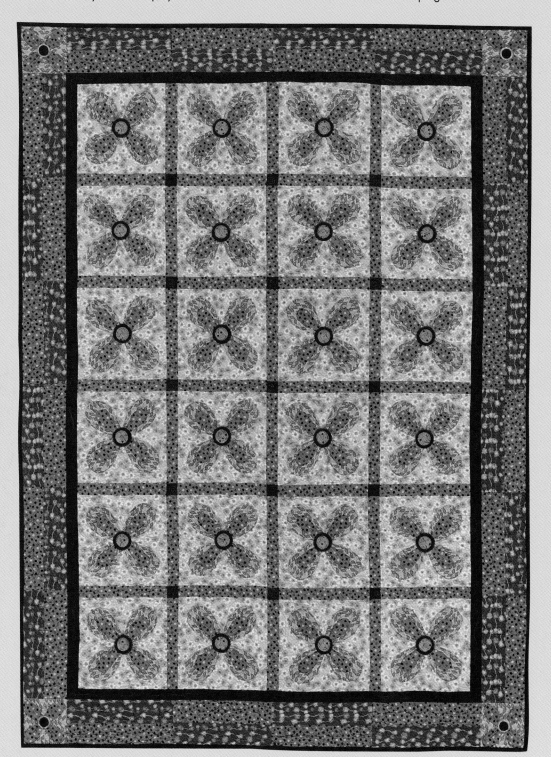

Made by Christine Kamon of Chester Springs, Pennsylvania

PUEBLA POSIES

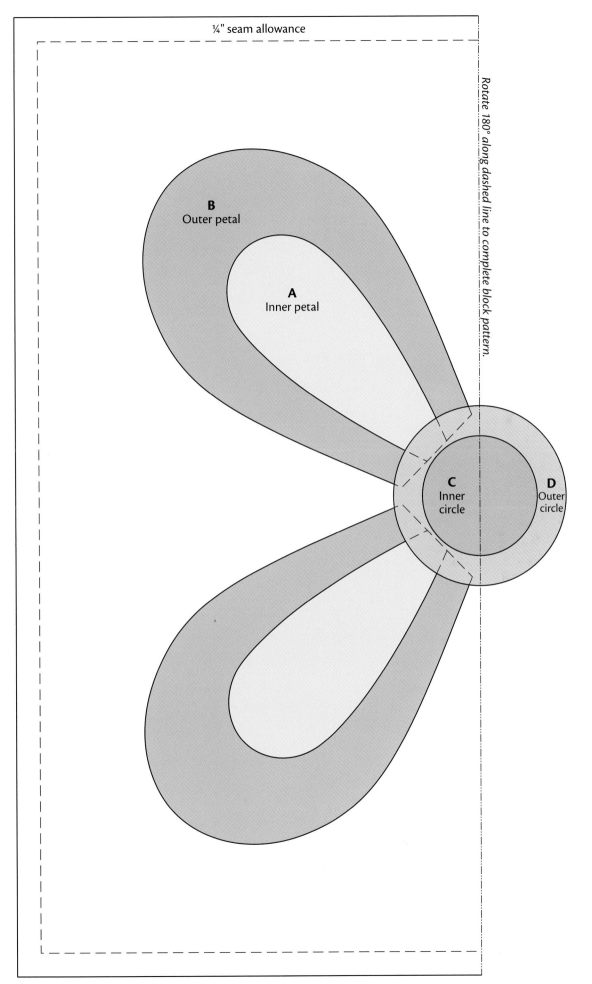

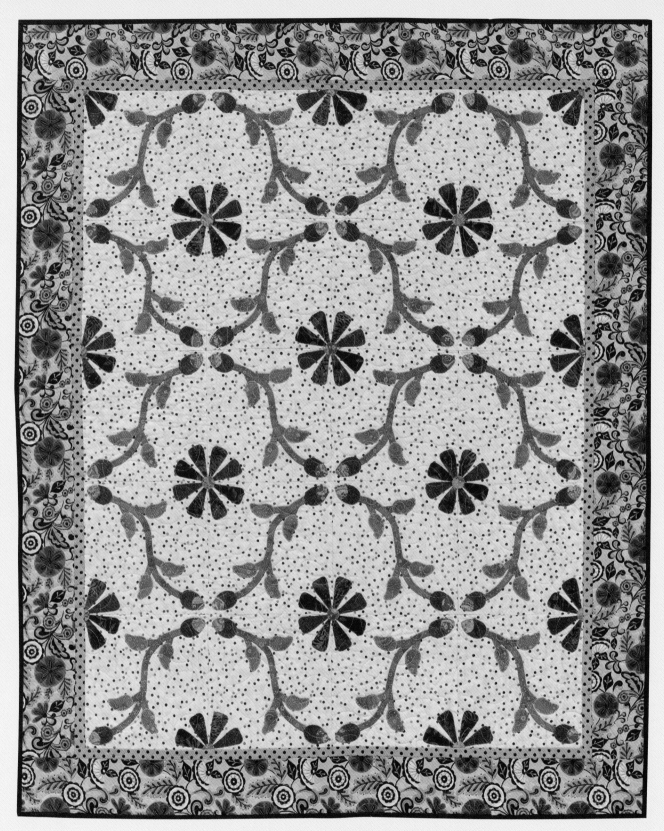

Finished quilt: 48" x 57½" • Finished blocks: 9½" x 9½"
Designed and made by Cheryl Lynch; machine quilted by Susie Racobaldo

Frida's Flowers

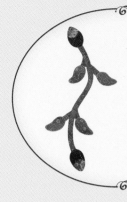

Artist Frida Kahlo is beloved as one of Mexico's national treasures. Her image appears on everything from shopping bags to pillows to charm bracelets. Her death in 1954 ended years of pain from a debilitating bus accident. That pain was reflected in her disturbing, surrealistic paintings—but in her home's garden, there was beauty and light. This quilt is a joyful tribute to Frida and her love for her garden.

MATERIALS

Yardage is based on 42"-wide fabric.

1⅝ yards of large-scale floral for outer border

1⅝ yards of yellow polka-dot fabric for block backgrounds*

½ yard of green tone-on-tone fabric for stems and leaves

¼ yard of green polka-dot fabric for inner border

¼ yard of orange tone-on-tone fabric for flower petals and bud bases

Fat eighth (9" x 21") of blue print for buds and flower centers

1 rectangle, 8" x 10", of *each of 3* additional orange tone-on-tone fabrics for flower petals

⅞ yard of orange tone-on-tone fabric for binding

3 yards of backing

53" x 63" piece of batting

2¼ yards of 17"-wide paper-backed fusible web

**If the fabric has less than 40" usable width after washing and putting on grain, you'll need 2⅛ yards.*

CUTTING

Cut all pieces across the width (crosswise grain) of the fabric unless otherwise noted. When the strip length is given as 42", cut from selvage to selvage across the full width of fabric.

From the yellow polka-dot fabric, cut:
5 strips, 10" x 42"; crosscut into 20 squares, 10" x 10"

From the green polka-dot fabric, cut:
5 strips, 1¼" x 42"

From the large-scale floral, cut along the *lengthwise* grain:
2 strips, 4½" x 50"

2 strips, 4½" x 51½"

From the orange binding fabric, cut:
1 square, 26" x 26"

APPLIQUÉ PIECES

Use the patterns on pages 44 and 45 to create the appliqué pieces, referring to "Preparing the Appliqués" on page 15 as needed.

From the green tone-on-tone fabric, cut*:
15 bias strips, ½" wide; crosscut into:

 20 pieces, 11" long

 80 pieces, 1½" long

40 of leaf A

40 of leaf B

From the ¼ yard of orange tone-on-tone fabric, make:
40 of bud base C

20 of petal E

From the blue print, make:
40 of bud D

15 of circle F

From *each* of the 3 orange tone-on-tone rectangles, make:
20 of petal E (60 total)

**See cutting diagram.*

Cutting diagram for green tone-on-tone fabric

design decisions

Believe it or not, this simple white tile was the inspiration for my colorful quilt. The choice of bright colors brings the quilt block to life. The yellow polka-dot background fabric, as an alternative to a solid color, gives the quilt a playful feeling. When set together, the curving vines form a lattice that moves your eye around the finished quilt. The buds come together in two of the block corners to form a secondary design. Although the orange flower petals weren't in the original tile design, they fill the open space with a touch of whimsy.

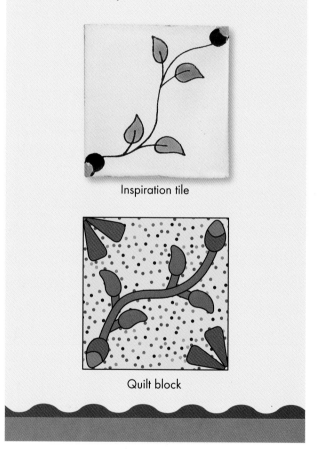

Inspiration tile

Quilt block

ASSEMBLING THE BLOCKS

Refer to "Fusible Appliqué" on page 15 as needed.

1. Using a light source, a water-soluble marker, and the patterns on pages 44 and 45, transfer the stem lines to the yellow 10" background blocks. First mark lines for the centers of the stems (the four side stems as well as the main stem) on 10 of the blocks. Then flip the pattern and mark a mirror image of the design on the 10 remaining blocks.

Mark 10 blocks. Mark 10 blocks.

2. Place and fuse the side stems, following the marked lines. Blanket-stitch around the edges that won't be covered by the main stems.

3. Place and fuse the main stems, making sure you leave enough stem to be covered by the buds.

4. Fuse each bud base C to a bud D, without removing the paper backing from D. Trim bud D if necessary so that it does not peek out from bud base C.

5. Fuse leaves A and B, the C/D bud units, and the petal E pieces to the background blocks using the block pattern on pages 44 and 45 for placement. Blanket-stitch around the pieces.

 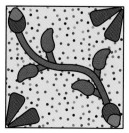

Make 10. Make 10.

ASSEMBLING THE QUILT TOP

Refer to "Quilt Construction" on page 20 for details if needed.

1. Referring to the quilt layout diagram below, lay out the center of the quilt top with four blocks across and five blocks down, alternating the blocks as shown.

2. Sew the blocks together. Press the seam allowances in opposite directions from row to row. (At this point, don't worry that the small ends of the orange petals aren't completely in the seam allowance.)

3. Fuse the circle F pieces to the centers of the orange flowers. On the outer edges and the corners of the quilt top, trim these circles so that they are even with the edge of the quilt. Blanket-stitch around the F pieces.

4. Measure through the center of the quilt top vertically to obtain the correct length for the inner side borders. Stitch together the 1¼"-wide green polka-dot strips, and then trim two lengths to this measurement. Attach to the sides of the quilt top. Press.

5. Repeat step 4 to add the top and bottom inner borders, measuring horizontally to determine the width of the quilt.

6. Repeat steps 4 and 5 to add the 4½"-wide floral outer border, attaching the side strips first. Press.

Quilt layout

FINISHING THE QUILT

1. Prepare a 52" x 62" backing by either creatively piecing one or using the fabric listed in the materials list. If using the listed yardage, remove the selvages and cut it in half crosswise. Sew together along the long edges and press the seam allowance to one side. Trim the excess.

2. Prepare a label and sew it to the back of the quilt.

3. Layer the quilt top, batting, and backing; baste.

4. Decide on a quilting design and mark the quilt if necessary. The quilt shown on page 40 was professionally quilted with an allover leaf pattern.

5. Use the 26" x 26" square of orange tone-on-tone fabric to bind with 2¼" bias binding. (See "Binding" on page 24.)

change it up

With the bright teal background, and sunflowers to replace the stylized orange flowers that join the blocks, this wall hanging is reminiscent of the south of France. Needle-turn appliqué was used as an alternative to fusing and a blanket stitch.

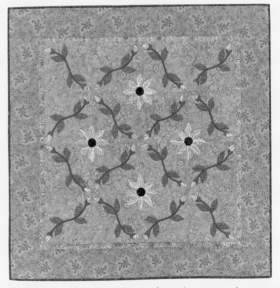

Made by June Wispelwey of Media, Pennsylvania

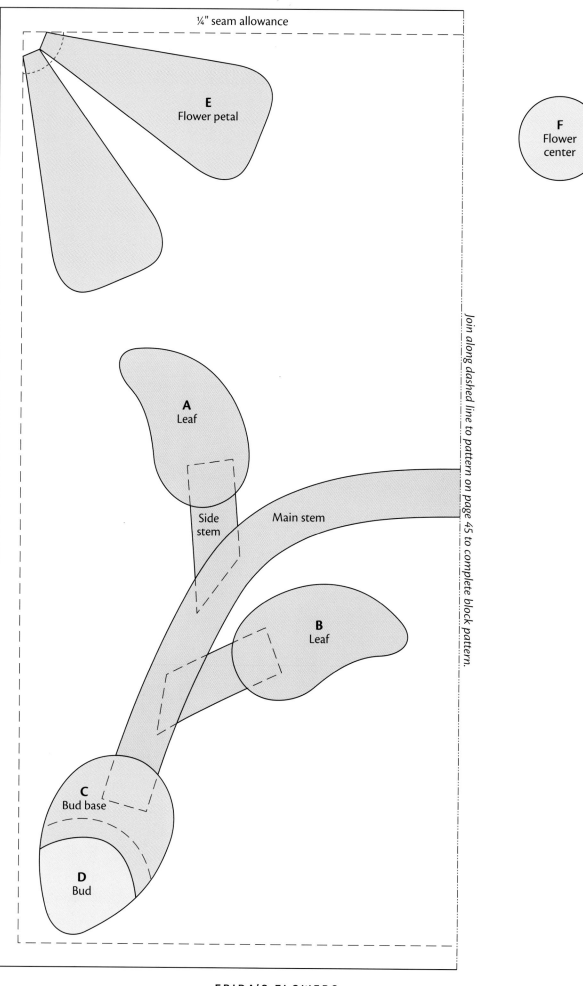

¼" seam allowance

E
Flower petal

F
Flower center

A
Leaf

Side stem

Main stem

B
Leaf

C
Bud base

D
Bud

Join along dashed line to pattern on page 45 to complete block pattern.

FRIDA'S FLOWERS

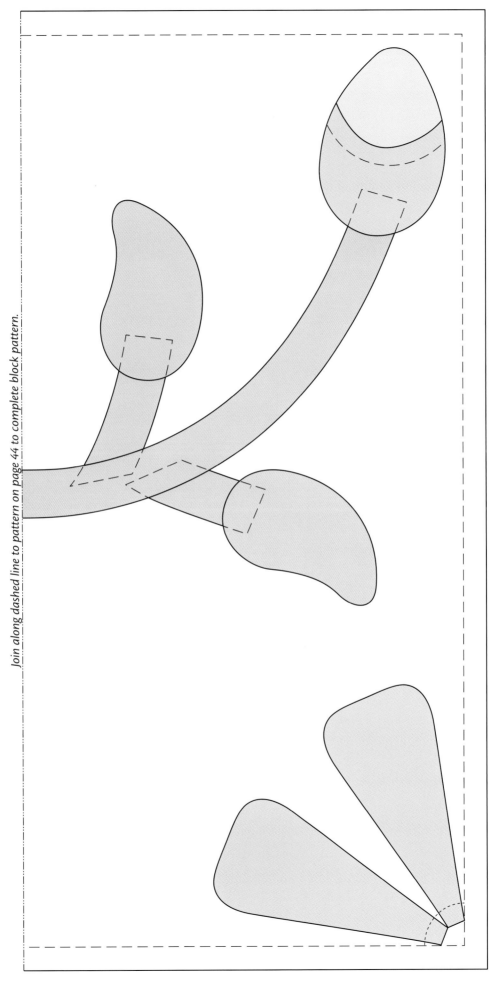

Join along dashed line to pattern on page 44 to complete block pattern.

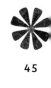

Finished quilt: 49½" x 59" • Finished blocks: 9½" x 9½"
Designed and made by Cheryl Lynch; machine quilted by Takako Pike

Black Bean Mole

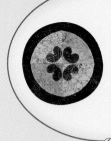

Mole is considered the national sauce of Mexico. The recipe has many variations, but they all include chocolate, chilies, garlic, onion, and a multitude of 30 or so other ingredients. This scrappy quilt is like a mole sauce. It's made of many different fabrics that blend together to yield a complex and intoxicating result.

MATERIALS

Yardage is based on 42"-wide fabric.

1⅛ yards of black batik 1 for block background and binding*

1 yard of black batik 2 for outer border

⅜ yard of black batik 3 for block background and border corner appliqués*

⅓ yard *each* of black batiks 4, 5, and 6 for block background*

⅝ yard of burnt orange batik 1 for block center and corner appliqués and border triangles

½ yard of burnt orange batik 2 for block center and corner appliqués and inner border

⅜ yard of burnt orange batik 3 for block center and corner appliqués and border corner squares

¼ yard *each* of burnt orange batiks 4 and 5 for block center and corner appliqués

Fat eighth (9" x 21") *each* of 8 assorted off-white or cream batiks for blocks

3¼ yards of backing

55" x 64" piece of batting

4½ yards of 17"-wide paper-backed fusible web

If the fabric is less than 40" wide after washing and putting on grain, add ⅓ yard more.

CUTTING

Cut all pieces across the width (crosswise grain) of the fabric unless otherwise noted. When the strip length is given as 42", simply cut from selvage to selvage across the full width of fabric.

From the black batik 1, cut:
1 strip, 10" x 42"; crosscut into 4 squares, 10" x 10"

1 square, 26" x 26"

From each of the black batiks 3, 4, 5, and 6, cut:
1 strip, 10" x 42"; crosscut into 4 squares, 10" x 10" (16 total)

From the black batik 2, cut:
6 strips, 4" x 42"; crosscut into:

 50 squares, 4" x 4"

 4 rectangles, 4" x 4¼"

 4 rectangles, 4" x 4½"

5 strips, 1½" x 42"

From the burnt orange batik 2, cut:
5 strips, 1½" x 42"

From the burnt orange batik 1, cut:
18 rectangles, 4" x 6"

From the burnt orange batik 3, cut:
4 squares, 5" x 5"

APPLIQUÉ PIECES

Use the patterns on page 51 to create the appliqué pieces, referring to "Preparing the Appliqués" on page 15 as needed.

From each of the 5 burnt orange batiks, make:
4 of block center A (20 total)

16 of corner bean B (80 total)

From each of the 8 assorted off-white or cream batiks, make:
10 of quarter circle C (80 total)

From the black batik 3, make:
4 of border corner D

In choosing this tile for inspiration, the first thing I noticed was that the corners were quarter circles. This meant that a full circle would be formed at the junction where four blocks came together. Although I could have used the same fabric for all the corners, that would not have been very interesting. Choosing to use eight different fabrics for the corners really gave the secondary pattern a lot of impact.

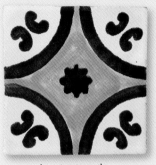

Inspiration tile

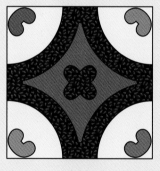

Quilt block

ASSEMBLING THE APPLIQUÉ BLOCKS

Refer to "Fusible Appliqué" on page 15 as needed.

When choosing which appliqué pieces A, B, and C to stitch to each black background, I decided to be very methodical, since this is a scrappy quilt. Each black background fabric has mostly the same combination of corner and central fabrics, so that when the quilt top is assembled, it will be easier to make sure that matching fabrics won't be next to each other.

1. Remove the fusible web backing paper from corner bean B appliqué pieces only. Place and fuse them to the quarter circle C appliqués. Blanket-stitch in place.

2. Refer to the pattern on page 51 to position the B/C units and A appliqué pieces on the black 10" background squares. Fuse and blanket-stitch the pieces in place.

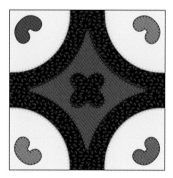

ASSEMBLING THE QUILT TOP

Refer to "Quilt Construction" on page 20 for details if needed.

1. Referring to the quilt layout diagram on the opposite page, lay out the quilt top into five rows of four blocks each, making sure that the same fabrics are not adjacent to each other. Sew the blocks together, pressing the seam allowances in opposite directions from row to row.

2. Measure the length of the quilt top through the center. Stitch together the 1½" burnt orange strips, and then cut two pieces to this measurement for the side inner borders. Sew to the sides of the quilt top and press.

3. Repeat step 2 to add the top and bottom inner borders, measuring horizontally through the center of the quilt top to obtain the correct length. Sew to the quilt top and press.

4. Prepare 18 floating triangle units for the outer border. Place a 4" x 4" black square, wrong sides together, on one side of a 4" x 6" burnt orange rectangle. Stitch in half along the diagonal. Press the fabric toward the corner along the diagonal seam to form a triangle; trim the seam to ¼".

5. Repeat step 4 on the other side of the rectangle.

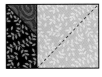

Make 18.

6. Assemble the outer side borders and the outer top and bottom borders as shown below, using the floating triangle units from step 5, the remaining black 4" x 4" squares, 4" x 4¼" rectangles, and 4" x 4½" rectangles.

7. Prepare the strips to connect the pieced outer border to the inner border by sewing together the 1½" strips of black batik. Measure the length of the quilt top through the center and trim two strips to this length. Attach the strips to the pieced side borders from step 6. If the pieced borders are too short, let out a couple of seams and take a smaller seam allowance. If the pieced borders are too long, trim the end rectangles evenly to fit.

8. Measure the width of the quilt top through the center and trim two 1½" black batik strips to this length. Attach to the pieced top and bottom borders from step 6, adjusting the pieced borders to fit.

9. Fuse and blanket-stitch an appliqué D piece to each of the four burnt orange 5" border corner squares.

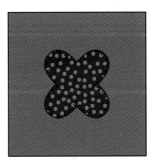

10. Attach a corner square to each end of the top and bottom outer borders. Press toward the corner squares.

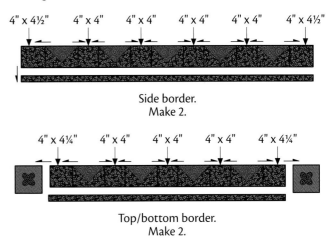

Side border.
Make 2.

Top/bottom border.
Make 2.

11. Sew the outer side borders to the sides of the quilt top. Press toward the inner border. Sew the top and bottom borders to the quilt top. Press.

FINISHING THE QUILT

1. Prepare a 54" x 63" backing by either creatively piecing one or using the fabric listed in the materials list. If using the listed yardage, remove the selvages and cut it in half crosswise. Sew the two pieces together along the long edges and press the seam allowance to one side. Trim the excess.

2. Prepare a label and sew it to the back of the quilt.

3. Layer the quilt top, batting, and backing; baste.

4. Decide on a quilting design and mark the quilt if necessary. The quilt shown on page 46 was quilted professionally with beige thread using an allover scroll design.

5. Use the 26" x 26" square of black batik to bind with 2¼" bias binding. (See "Binding" on page 24.)

change it up

The choice of blue and white fabrics gives this quilt a light, summery feel.

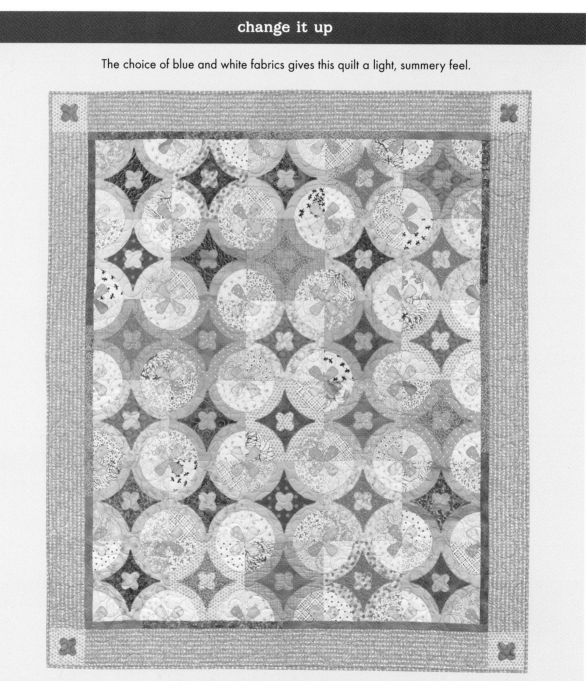

Made by Cheryl Lynch; quilted by Susie Racobaldo

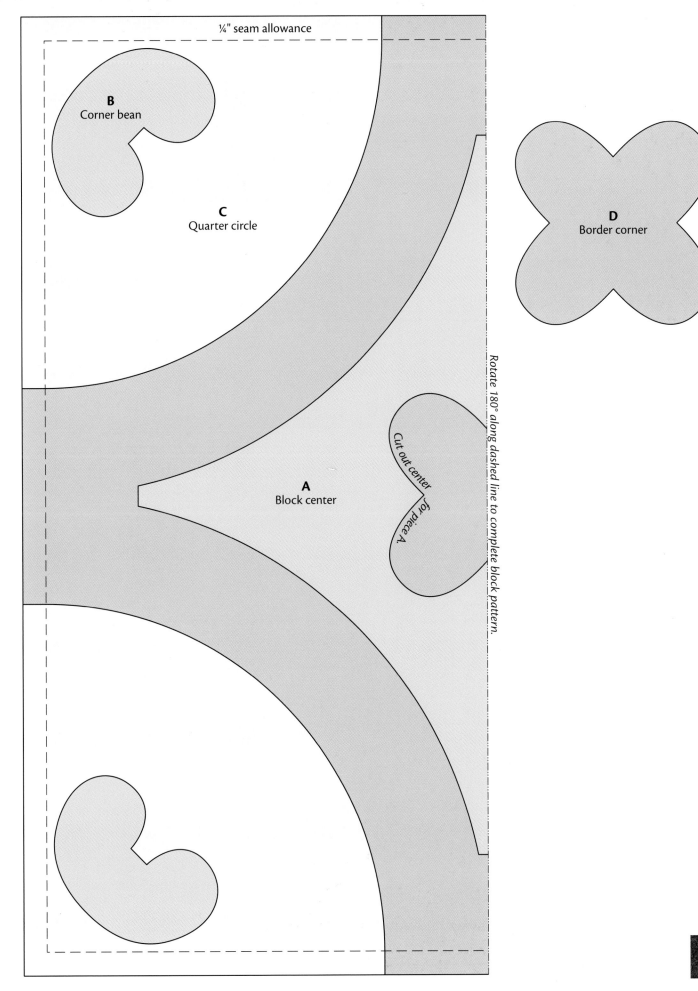

B
Corner bean

C
Quarter circle

A
Block center

Cut out center for piece A

¼" seam allowance

Rotate 180° along dashed line to complete block pattern.

D
Border corner

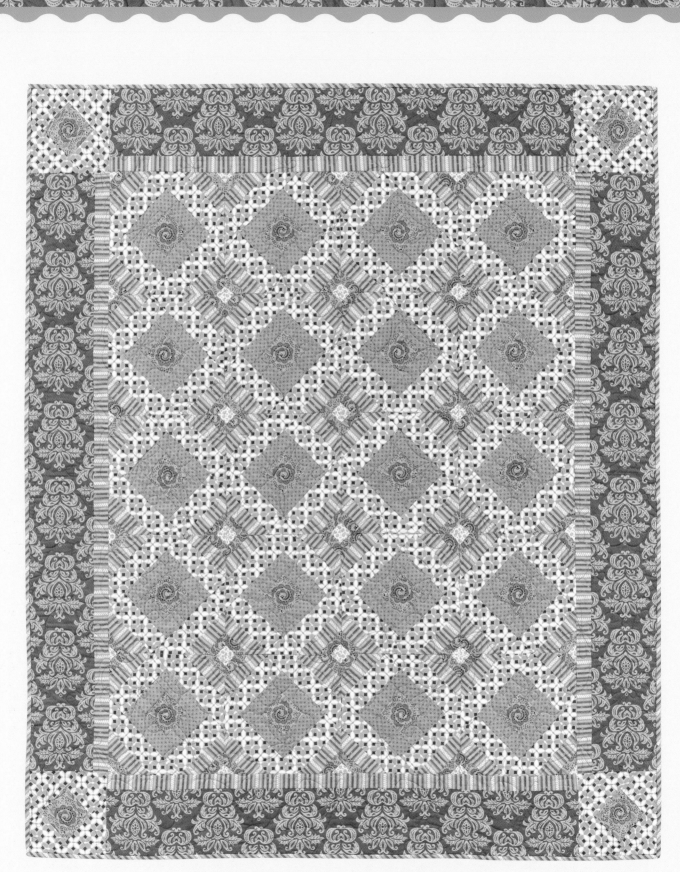

Finished quilt: 51½" x 61" • Finished blocks: 9½" x 9½"
Designed and made by Cheryl Lynch; machine quilted by Susie Racobaldo

Salsa Verde

Salsa is basic to Mexican cuisine, used as commonly as ketchup is enjoyed in the United States. Salsa verde, or green salsa, has tomatillos rather than red tomatoes as the main ingredient.

MATERIALS

Yardage is based on 42"-wide fabric.

1⅝ yards of white-and-green print for strip 2 around block center and border corner squares

1⅝ yards of striped fabric for strip 3 around block center, inner border, and bias binding

1½ yards of green floral for outer border

⅝ yard of green snail print for block center, strip 4 around block center, and border corner squares

½ yard of teal dot fabric for first strip around block center

¼ yard of ladybug print for block corners

3¼ yards of backing

57" x 66" piece of batting

Foundation paper

CUTTING

Cut all pieces across the width (crosswise grain) of the fabric unless otherwise noted. When the strip length is given as 42", simply cut from selvage to selvage across the full width of fabric.

From the green snail print, cut:

2 strips, 3" x 42"; crosscut into 20 squares, 3" x 3"

3 strips, 3½" x 42"; crosscut into:

 80 rectangles, 1¼" x 3½"

 4 squares, 3½" x 3½"

From the teal dot fabric, cut:

9 strips, 1¾" x 42"; crosscut into:

 40 rectangles, 1¾" x 3"

 40 rectangles, 1¾" x 5½"

From the white-and-green print, cut:

17 strips, 2¼" x 42"; crosscut into:

 40 rectangles, 2¼" x 6"

 40 rectangles, 2¼" x 10"

2 strips, 6" x 42"; crosscut into 8 squares, 6" x 6". Cut each square in half diagonally to yield 16 triangles.

From the striped fabric, cut*:

1 square, 26" x 26"

80 rectangles, 1¾" x 6"

5 strips, 1¾" x 42"

From the ladybug print, cut:

5 strips, 1½" x 42"; crosscut into 80 rectangles, 1½" x 2½"

From the green floral, cut along the *lengthwise* grain:

2 strips, 5¾" x 40½"

2 strips, 5¾" x 50"

**See cutting diagram.*

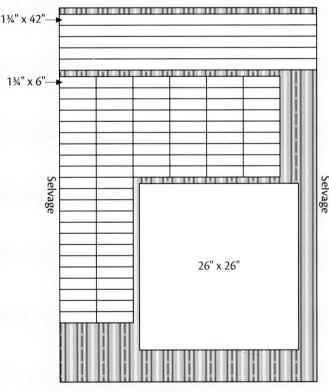

1¾" x 42"

1¾" x 6"

Selvage

Selvage

26" x 26"

Cutting for striped fabric

design decisions

This striped tile inspired the block design for "Salsa Verde." To minimize having to piece bias edges, four of these tiles were put together to make the quilt block. Striped fabric always makes a pattern look more complicated, like it does for this quilt. Although the square formed from the secondary design in the corners is small, it's well balanced due to the contrast.

Inspiration tile

Quilt block

ASSEMBLING THE BLOCKS

Refer to "Foundation Paper Piecing" on page 18 as needed.

1. Using the pattern on pages 58 and 59, paper piece 20 blocks for the quilt center. Trim to 10" x 10".

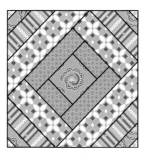

Make 20.

2. Using the pattern on page 57, paper piece four blocks for the border corners. Trim to 7" x 7".

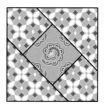

Make 4.

ASSEMBLING THE QUILT TOP

Refer to "Quilt Construction" on page 20 for details if needed.

1. Lay out the center of the quilt top with four blocks across and five blocks down. Sew the blocks into rows, and then sew the rows together, pressing the seam allowances in opposite directions from row to row.

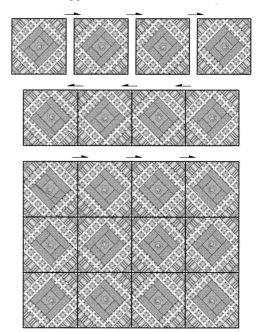

2. Measure through the center of the quilt top vertically to obtain the correct length for both the inner and outer side borders. Stitch together three of the 1¾" strips of striped fabric, and then cut two strips to this measurement. Trim the 5¾" x 50" green floral strips to this measurement also. Stitch the inner borders to the outer borders and sew to the sides of the quilt top. Press toward the borders.

3. Before attaching the side borders, measure through the center of the quilt top horizontally to obtain the correct measurement for both the inner and outer top and bottom borders. Trim the remaining 1¾" striped strips and 5¾" x 40½" green floral strips to this measurement. Stitch the inner borders to the outer borders. Press.

4. Sew a border corner block to each end of the top and bottom borders. Press toward the borders.

5. Attach the top and bottom borders to the quilt top. Press.

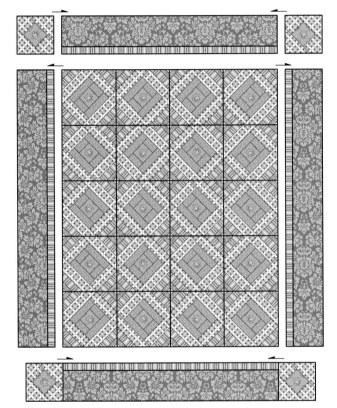

Quilt layout

6. Remove the paper foundation from the back of the quilt top.

FINISHING THE QUILT

1. Prepare a 56" x 65" backing by either creatively piecing one or using the fabric listed in the materials list. If using the listed yardage, remove the selvages and cut it in half crosswise. Sew together along the long edges and press the seam allowance to one side. Trim the excess.

2. Prepare a label and sew it to the back of the quilt.

3. Layer the quilt top, batting, and backing; baste.

4. Decide on a quilting design and mark the quilt if necessary. The quilt shown on page 52 was professionally machine quilted with an allover pattern of a flying dragonfly.

5. Use the 26" x 26" square of striped fabric to bind with 2¼" bias binding. (See "Binding" on page 24.)

change it up

This wall hanging demonstrates the use of the Salsa Verde block as a border, featuring another typical calla lily tile block as the center.

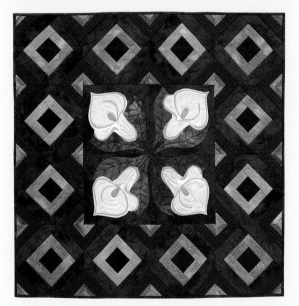

Made by Terry Kramzar
of Kennett Square, Pennsylvania

This bed quilt combines the Salsa Verde block along with circular elements from some of the other quilt designs. It was custom fit for a particular bed with the scalloped border and cutout corners.

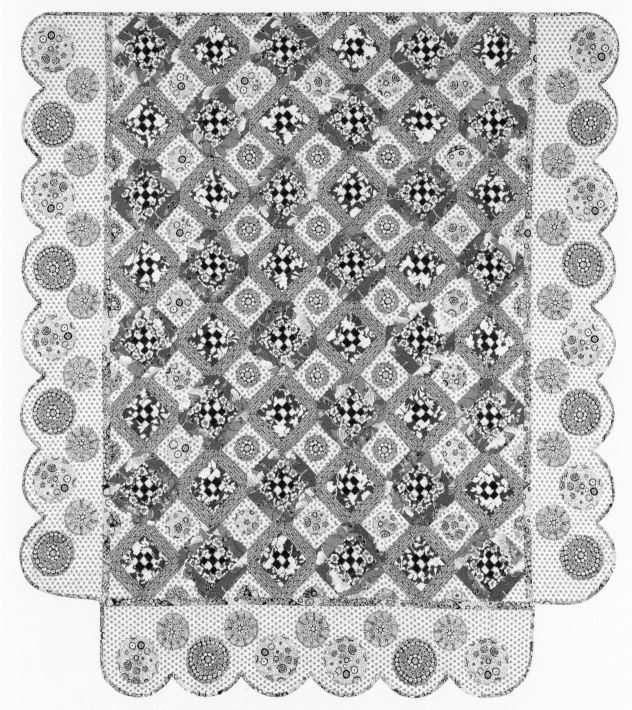

Made by Lisa O'Neill of Malvern, Pennsylvania; quilted by Barbara Persing

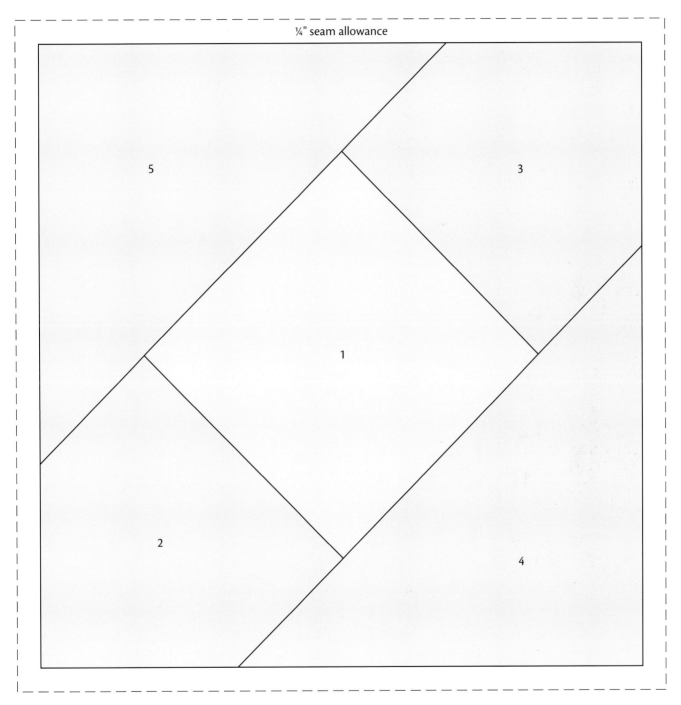

¼" seam allowance

Corner foundation pattern

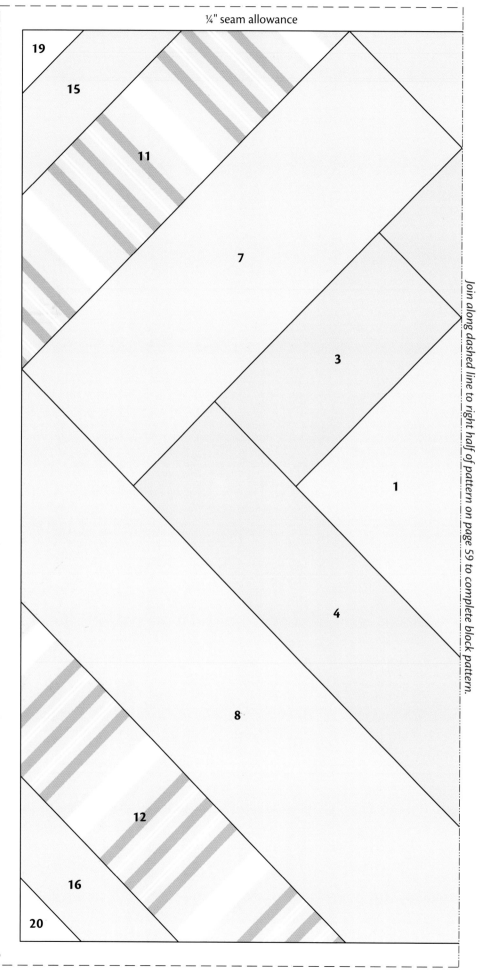

¼" seam allowance

19

15

11

7

3

1

4

8

12

16

20

¼" seam allowance

Join along dashed line to right half of pattern on page 59 to complete block pattern.

**Block foundation
pattern (left half)**

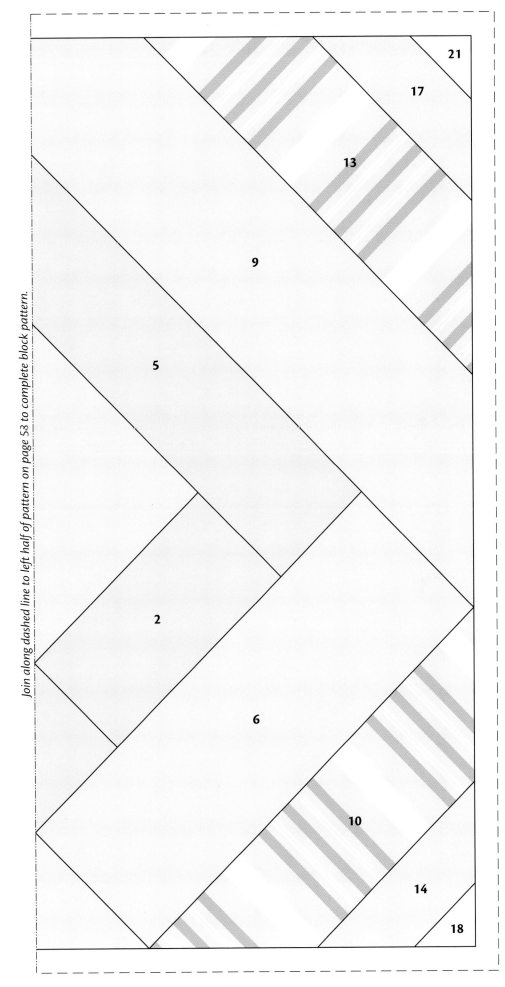

Block foundation pattern (right half)

Join along dashed line to left half of pattern on page 53 to complete block pattern.

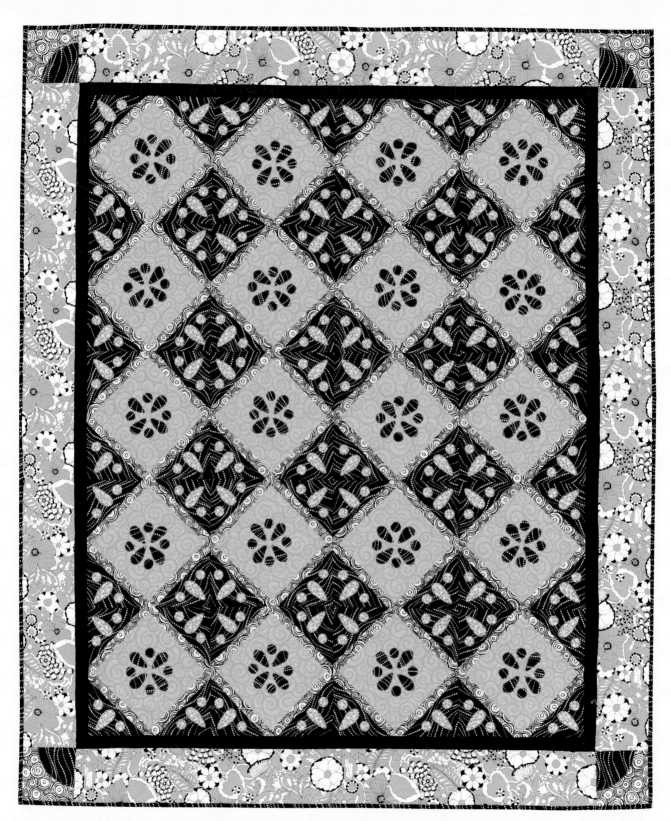

Finished quilt: 48½" x 58" • Finished blocks: 9½" x 9½"
Designed and made by Cheryl Lynch; machine quilted by Linda Mendenhall

Jalapeño Poppers

Chili peppers are important in Mexican cooking. Each variety is chosen as an ingredient in a recipe for its individual flavor. Of more than 140 varieties of chili peppers grown in Mexico, the jalapeño pepper is the most commonly used. It has a heat level that ranges from mild to hot, based on its cultivation. A common misconception is that the seeds give a pepper the heat. It's really the fleshy veins. Sometimes this pepper is stuffed, usually with seasoned cheese, and then deep-fried and served as an appetizer called a "popper."

MATERIALS

Yardage is based on 42"-wide fabric.

1⅞ yards of black dot print for block corners; small petal, circle, and quarter-circle appliqués; and bias binding

1½ yards of large-scale green floral for outer border

⅞ yard of lime green tone-on-tone fabric for block centers

⅞ yard of black-and-white circle print for block strips and border corner squares

⅜ yard of green dot print for circle and large petal appliqués

⅓ yard of black solid for inner border

3 yards of backing

54" x 63" piece of batting

1½ yards of 17"-wide paper-backed fusible web

Foundation paper

CUTTING

Cut all pieces across the width (crosswise grain) of the fabric unless otherwise noted. When the strip length is given as 42", simply cut from selvage to selvage across the full width of fabric.

From the lime green tone-on-tone fabric, cut:
4 strips, 6½" x 42"; crosscut into 20 squares, 6½" x 6½"

From the black-and-white circle print, cut:
18 strips, 1¼" x 42"; crosscut into:

 40 rectangles, 1¼" x 7"

 40 rectangles, 1¼" x 8½"

1 strip, 4½" x 18"; crosscut into 4 squares, 4½" x 4½"

From the black dot print, cut:
5 strips, 5" x 42"; crosscut into 40 squares, 5" x 5".
Cut each square in half diagonally to yield 80 triangles.

1 square, 26" x 26"

From the black solid, cut:
5 strips, 1½" x 42"

From the large-scale green floral, cut along the *lengthwise* grain:
2 strips, 4½" x 52"

2 strips, 4½" x 42½"

APPLIQUÉ PIECES

Use the patterns on pages 63–65 to create the appliqué pieces, referring to "Preparing the Appliqués" on page 15 as needed.

From the black dot print, make:
80 of small petal A

80 of circle B

4 of quarter-circle D

From the green dot print, make:
160 of circle B

80 of large petal C

Choosing black, white, and green fabrics for this quilt made it very vibrant, so I limited the fabrics to only those colors. The contrast with the black and white really made the green "pop." The stripes formed by the white dots on the black fabric resulted in a complex design at the junction of the corners. This gave the secondary design a high level of interest. Any type of striped fabric, especially a wavy stripe, would work as well.

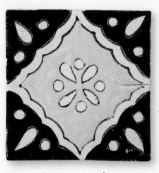

Inspiration tile

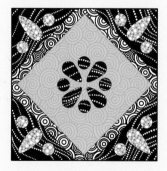

Quilt block

ASSEMBLING THE BLOCKS

Refer to "Fusible Appliqué" on page 15 and "Foundation Paper Piecing" on page 18 as needed.

1. Paper piece the block using the patterns on pages 64 and 65. Trim to 10" x 10".

2. Remove the paper from the blocks, being careful not to distort them. Fuse small petal A, circle B, and large petal C appliqués in place using the patterns on pages 64 and 65 for placement.

3. Stitch all the appliqués with a blanket stitch.

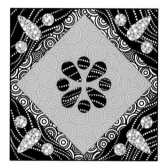

Make 20.

ASSEMBLING THE QUILT TOP

Refer to "Quilt Construction" on page 20 for details if needed.

1. Referring to the quilt layout diagram on the opposite page, assemble the quilt center with four blocks across and five blocks down. Press the seam allowances in opposite directions from row to row.

2. Measure through the center of the quilt top vertically to obtain the correct length for the inner side borders. Stitch together the 1½" strips of black solid fabric, and then cut two strips to this measurement. Sew to the sides of the quilt top. Press.

3. Repeat step 2 to add the top and bottom inner borders, measuring horizontally through the center of the quilt top to obtain the correct length. Sew the borders to the quilt top and press.

4. Fuse and blanket-stitch each quarter-circle D to a 4½" circle print square to make the four border corner squares.

5. Measure through the center of the quilt top vertically to obtain the correct length for the outer side borders. Trim the 4½" x 52" green floral strips to this measurement. Sew to the sides of the quilt and press toward the borders.

6. Measure through the horizontal center of the quilt to determine the correct length for the outer top and bottom borders. Trim the 4½" x 42½" green floral strips to this measurement. Attach a border corner square to each end of the top and bottom borders, being careful to rotate them so the black dot quarter-circles will be closest to the quilt center. Press the seam allowances toward the green floral and sew to the quilt.

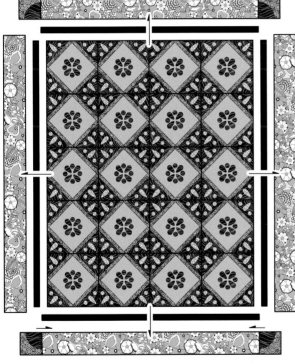

Quilt layout

FINISHING THE QUILT

1. Prepare a 53" x 62" backing by either creatively piecing one or using the fabric listed in the materials list. If using the listed yardage, remove the selvages and cut it in half crosswise. Sew together along the long edges and press the seam allowance to one side. Trim the excess.

2. Prepare a label and sew it to the back of the quilt.

3. Layer the quilt top, batting, and backing; baste.

4. Decide on a quilting design and mark the quilt if necessary. The quilt shown on page 60 was professionally quilted with an allover scroll pattern.

5. Use the 26" x 26" square of black dot print to bind with 2¼" bias binding. (See "Binding" on page 24.)

change it up

The use of lower-contrast analogous colors of gold and yellow, complemented by the borders with red, gold, orange, and green, gives this version an autumn feel.

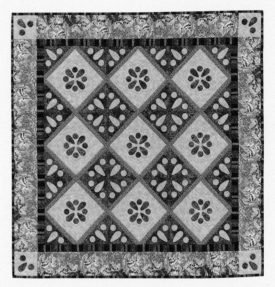

Made by Lin Buchta of Brookhaven, Pennsylvania

D
Quarter circle

¼" seam allowance

¼" seam allowance

8

B
Circle

C
Large petal

4

A
Small petal

1

B
Circle

2

7

¼" seam allowance

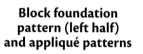

Join along dashed line to right half of pattern on page 65 to complete block pattern.

**Block foundation
pattern (left half)
and appliqué patterns**

**Block foundation
pattern (right half)**

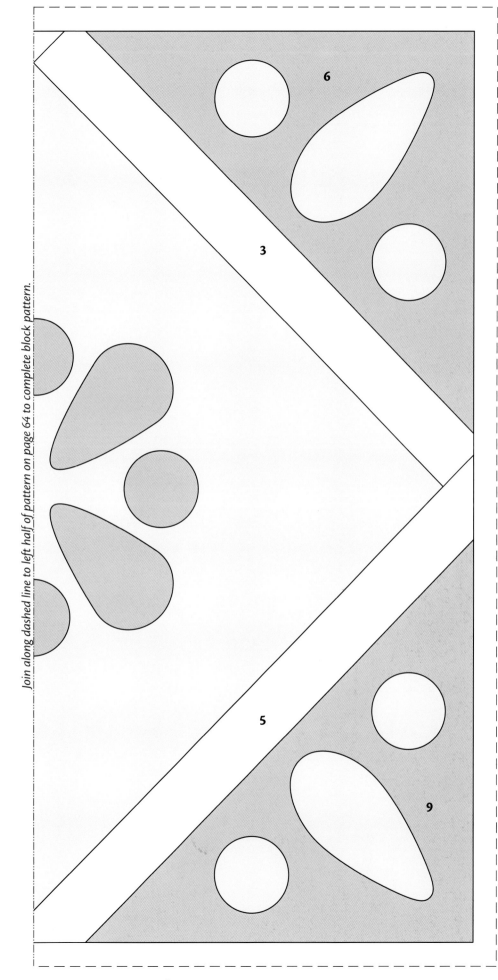

Join along dashed line to left half of pattern on page 64 to complete block pattern.

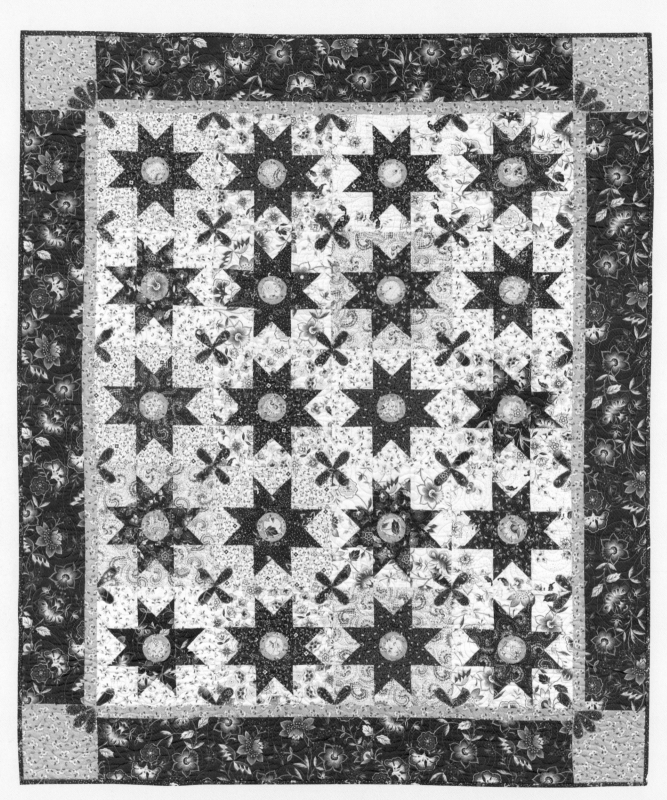

Finished quilt: 50½" x 60" • Finished blocks: 9½" x 9½"
Designed and made by Cheryl Lynch; machine quilted by Susie Racobaldo

Casa **Talavera**

Puebla is one of the most beautiful Mexican colonial cities. Most of the tiles that adorn the exteriors of the buildings are blue and white. Back in the sixteenth century these colors were reserved for the finest of the tiles, as determined by the Potter's Guild Ordinances. The mineral pigments needed to produce the blue glaze were the scarcest and most expensive, so while tiles on the facade of your home meant you were wealthy, blue tiles elevated you to the most wealthy.

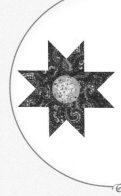

MATERIALS

Yardage is based on 42"-wide fabric.

Casa Talavera is meant to be a scrappy quilt. I used six background fabrics and seven dark blue star fabrics, but you can use as many different prints as you like. For each block, I used one white-with-blue print for the background and one dark blue print for the stars and petals, but you can use different fabrics.

Yardage is given for one block. *Multiply the yardage by the number of blocks you wish to make of a particular fabric. For example, for the backgrounds I made two blocks out of one of the fabrics (¼ yard), three blocks each from two of the fabrics (⅜ yard each), and four blocks each out of three of the fabrics (½ yard each).*

1½ yards of dark blue fabric for outer border. There will be enough left over for the stars and petals for 4 blocks.

⅞ yard of dark blue fabric for binding. There will be enough left over for the stars and petals for 3 blocks.

⅝ yard of light blue print for outer circle appliqué, inner border, and border corner squares

⅛ yard of dark blue print for *each* block's stars and petal appliqués

⅛ yard of white-with-blue print for *each* block's background and inner circle appliqué

3¼ yards of backing

56" x 65" piece of batting

1 yard of 17"-wide paper-backed fusible web

CUTTING

Cut all pieces across the width (crosswise grain) of the fabric unless otherwise noted. When the strip length is given as 42", simply cut from selvage to selvage across the full width of fabric.

For 1 star block, cut from the same dark blue print:*
8 squares, 3" x 3"

1 square, 3½" x 3½"

**Repeat for a total of 20 blocks from assorted dark blue fabrics.*

For 1 star block, cut from the same white-with-blue* print:
4 squares, 3¾" x 3¾"

4 rectangles, 3½" x 3¾"

**Repeat for a total of 20 blocks from assorted white-with-blue prints.*

From the light blue print, cut:
5 strips, 1½" x 42"

4 squares, 6½" x 6½"

From the dark blue outer-border fabric, cut along the *lengthwise* grain:
2 strips, 5½" x 40½"

2 strips, 5½" x 50"

From the dark blue binding fabric, cut:
1 square, 26" x 26"

design decisions

Blue and white is a perfect color duo for this quilt, since it's a very traditional American quilt combination. That said, any two contrasting colors would work. Floating the star points in the background not only helps to accentuate the secondary quilt design, but also preserves the precision of the block.

Inspiration tile

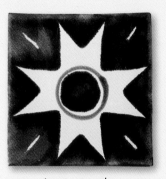

Quilt block

APPLIQUÉ PIECES

Use patterns on page 71 to create the appliqué pieces, referring to "Preparing the Appliqués" on page 15 as needed.

From assorted white-with-blue prints, make:
20 of inner circle A

From the light blue print, make:
20 of outer circle B

From assorted dark blue prints, make:
4 of petal C for each block and 12 of petal C for border corners (92 total)

MAKING THE APPLIQUÉS

Refer to "Fusible Appliqué" on page 15 as needed.

1. Remove the paper backing from only the inner circle A pieces. Place each inner circle in the center of an outer circle B. Fuse in place. Remove the paper backing from the outer circles and blanket-stitch around the inner circles.

2. Fuse an appliqué unit from step 1 to the center of each 3½" x 3½" dark blue center square. Stitch around the outer circles.

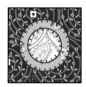

Make 1 per block
(20 total).

3. To prepare the corner squares for each block, fuse a petal C to a corner of each 3¾" x 3¾" white-with-blue print square. Blanket-stitch around the petals. Make four matching corner squares for each block.

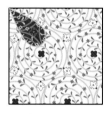

Make 4 per block
(80 total).

4. For the corner squares in the border, fuse and blanket-stitch three petal C pieces to each of the four 6½" x 6½" light blue squares using the pattern on page 71 for placement. Save these for assembling the quilt top.

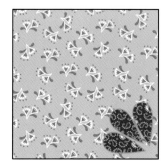

Make 4.

ASSEMBLING THE BLOCKS

1. To make the star-point units, place a 3" x 3" square of dark blue fabric on the corner of one of the 3½" x 3¾" white-with-blue print rectangles, right sides together. Stitch from corner to corner of the dark blue square.

2. Press the triangle toward the corner, lining it up with the background. Open it up and trim the two bottom layers ¼" from the seam. Repeat to make four matching units for each block (80 total).

3. For the second star point, place a 3" x 3" square along the shorter edge of the unit from step 2, right sides together as shown. Stitch from corner to corner of the dark blue square.

4. Press toward the corner, lining up the edges of the triangle with the background. Then lift the top triangle and trim the two bottom layers, ¼" from the seam. Make four matching star-point units for each block (80 total).

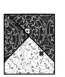

Make 4 per block
(80 total).

5. After preparing four star-point units, four corners with petal appliqués, and the center square with the circles, lay out the block.

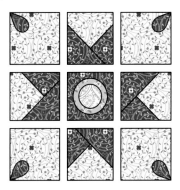

6. Sew the sections together by rows. Press the seam allowances for the top and bottom rows toward the outer corners and the seam allowances for the middle row toward the center square.

7. Sew the rows together to form the block. Make 20 blocks.

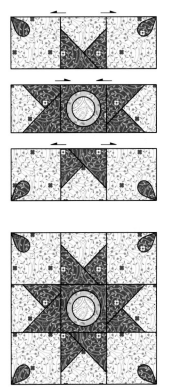

Make 20.

ASSEMBLING THE QUILT TOP

Refer to "Quilt Construction" on page 20 for details if needed.

1. Referring to the quilt layout diagram below, assemble the quilt center with four blocks across and five blocks down. Press the seam allowances in opposite directions from row to row.

2. Measure through the center of the quilt top vertically to obtain the correct length for both the inner and outer side borders. Stitch together three of the light blue 1½" strips, and then cut two strips to this measurement for the side inner borders. Trim the 5½" x 50" dark blue strips to this measurement also. Stitch the inner borders to the outer borders and sew to the sides of the quilt top. Press toward the outer borders.

3. Before attaching the side borders, measure through the center of the quilt top horizontally to obtain the correct measurement for both the inner and outer top and bottom borders. Trim the remaining 1½" strips and 5½" x 40½" dark blue strips to this measurement. Stitch the inner borders to the outer borders. Press.

4. Sew a border corner block to each end of the top and bottom borders, being careful to orient the petals correctly. Press toward the borders.

5. Attach the top and bottom borders to the quilt top. Press.

FINISHING THE QUILT

1. Prepare a 55" x 64" backing by either creatively piecing one or using the fabric listed in the materials list. If using the listed yardage, remove the selvages and cut it in half crosswise. Sew together along the long edges and press the seam allowance to one side. Trim the excess.

2. Prepare a label and sew it to the back of the quilt.

3. Layer the quilt top, batting, and backing; baste.

4. Decide on a quilting design and mark the quilt if necessary. The quilt shown on page 66 was professionally quilted using light blue thread and an allover swirl design.

5. Use the 26" x 26" square of dark blue fabric to bind with 2¼" bias binding. (See "Binding" on page 24.)

change it up

Casa Talavera can be designed with multiple colors. Brightly colored fabrics juxtaposed on black make the petals really shine.

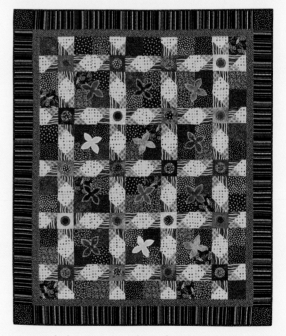

Made by Jane Hamilton of Kennett Square, Pennsylvania

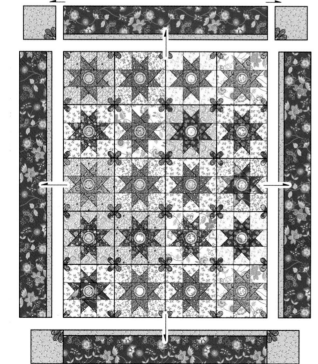

Quilt layout

C
Petal

Block corner square

A
Inner circle

B
Outer circle

¼" seam allowance

Border corner square

C
Petal

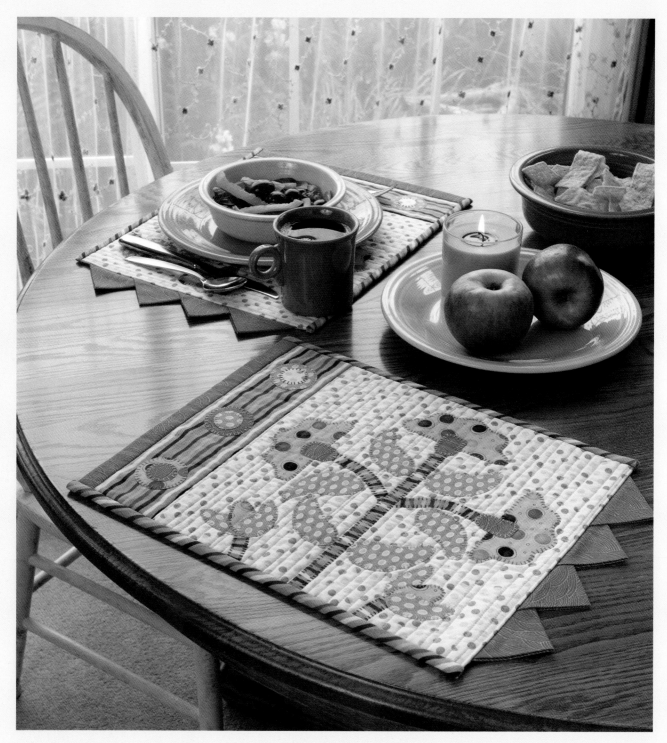

Place mat size: 12½" x 16"
Designed, pieced, hand appliquéd, and quilted by Cheryl Lynch

Floral **Fiesta**

Colorful place mats bring to mind the abundant fiestas that are an integral part of the Mexican culture. These festivities include processions, merriment, and often fireworks. Everything is cause for a celebration, including honoring a patron saint, Mexican Independence Day, and even praying for a good fishing season. As in all cultures, food is a very important part of any festival.

MATERIALS

Yardage is based on 42"-wide fabric. The materials and instructions will make 4 place mats.

⅞ yard of white dot print for background and circle appliqué

¾ yard of striped fabric for stems, left side of place mat, and top and bottom binding

½ yard of orange fabric for flower bases, prairie points, left binding, and circle appliqué

¼ yard of green fabric for leaves and circle appliqué

¼ yard of yellow fabric for flowers, buds, and circle appliqué

⅞ yard of backing fabric

4 squares, 18" x 18", of batting

1½ yards of 17"-wide paper-backed fusible web

CUTTING

Cut all pieces across the width (crosswise grain) of the fabric unless otherwise noted. When the strip length is given as 42", simply cut from selvage to selvage across the full width of fabric.

From the white dot print, cut:
4 squares, 14" x 14"

From the striped fabric, cut:
4 strips, 2½" x 12½", with stripes running parallel to the long edges

8 strips, 2½" x 16", with stripes on the diagonal

From the orange fabric, cut:
16 squares, 4" x 4"

4 strips, 4" x 12½"

From the backing fabric, cut:
4 rectangles, 12½" x 18"

APPLIQUÉ PIECES

Use the patterns on page 77 to create the appliqué pieces, referring to "Preparing the Appliqués" on page 15 as needed. Enlarge the block pattern 167%.

From the orange fabric, make:
12 of flower base D

4 of outer circle H

4 of inner circle I

From the yellow fabric, make:
12 of flower A

4 of outer circle H

8 of bud E

From the green fabric, make:
12 of leaf B

12 of leaf C

8 of leaf F

8 of leaf G

4 of outer circle H

4 of inner circle I

From the white dot print, make:
4 of inner circle I

From the striped fabric, cut:
1 rectangle, 12" x 5", with stripes running parallel to the short edges

design decisions

Quilting around appliqué pieces is always a challenge. Since this is a small piece, I quilted the background before adding the appliqués. After layering only the background fabric and the batting, I free-form parallel quilted. Then I added the appliqué pieces, and finally added the back toward the end of construction, providing a neatly finished look.

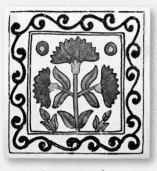

Inspiration tile

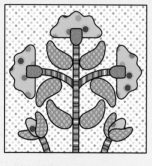

Quilt block

PLACE MAT PREPARATION

1. First quilt the background to only the batting. Position the 14" x 14" background square on the 18" x 18" batting and secure with straight pins. Quilt as desired.

2. Prepare the 12" x 5" striped rectangle with fusible web for the stems. Cut into nine strips, ½" x 12".

3. Referring to the pattern on page 77 for placement, fuse all the pieces for the main section of the place mat, centering the pattern on the background square and overlapping the pieces where there's a dashed line. Referring to "Stitching the Appliqués" on page 16, blanket-stitch or whipstitch around the pieces.

4. Remove the paper backing from only the small circle I pieces. Place each small circle in the center of a large circle H, referring to the photo on page 72 for color placement. Fuse in place. Remove the paper backing from the large circles and blanket-stitch around the small circles. Fuse and blanket-stitch three of the circle units to each 2½" x 12½" striped rectangle, positioning them as shown.

5. To prepare the prairie points, first fold a 4" orange square in half diagonally, wrong sides together. Press. I recommend using steam when pressing to achieve very flat pieces. Fold in half again, point to point, and press. Make four prairie points for each place mat (16 total).

Make 16.

CONSTRUCTING THE PLACE MAT

1. Mark a 12½" square on the main flower appliqué section, centering the flower stem vertically and with the base of the stems at the bottom edge of the square. (I like to use a 12½" square ruler and a water-soluble blue marker.)

2. Trim the top and bottom edges so the piece measures 12½" high. Trim the excess from the right edge but do not trim the left edge.

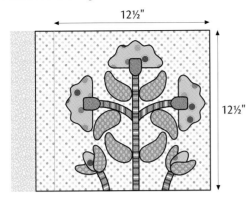

3. With the right side facing up, space the prairie points evenly along the right edge of the square, raw edges matching and with the points facing toward the largest flower stem. Leave a ½" space at both the top and the bottom. With the openings facing down, tuck the points into each other so that the triangles are spaced evenly along the edge. Pin, and then baste with the longest stitch of your sewing machine, ½" from the edge.

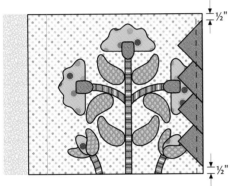

4. Place the 12½" x 18" piece of backing fabric, right side down, on top of the place mat top, aligning the side edge of the backing with the raw edge of the prairie points. Sew ¼" in from the side edge.

5. Trim out the batting from the seam allowance. Then press the backing away from the main body.

6. Remove the basting stitches from the prairie points. Fold the backing fabric to the back of the place mat, with the prairie points facing out. Press. Pin baste the backing to the top, and then topstitch ⅛" from the right edge through all the layers to stabilize the prairie points.

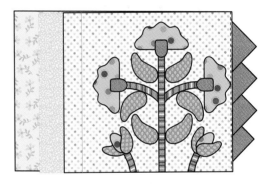

7. Align the strip with appliqué circles with the marking for the 12½" square on the left side of the block. Sew with a ¼" seam allowance through all layers.

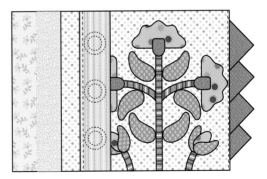

8. Press the strip to the side.

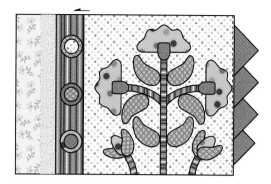

9. Fold a 4" x 12½" strip of orange fabric for the binding in half lengthwise, wrong sides together. Align the raw edges of the binding with the raw edge of the striped fabric and sew with a ¼" seam allowance.

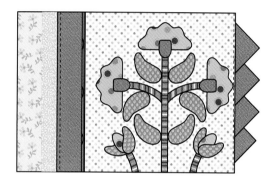

10. Trim the batting and backing ¾" from the seam. Press the binding away from the place mat.

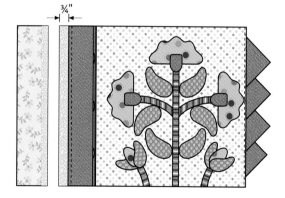

11. Turn the folded edge to the back, just covering the stitching line, and stitch the binding to the back with a hidden whipstitch.

12. To bind the top and bottom edges, press ½" to the wrong side on one of the short edges of 2½" x 16" strip of striped fabric. Fold in half lengthwise, wrong sides together, and press. Place the binding,

raw edges aligned, at the top edge of the place mat, starting with the edge of the binding that is pressed under. Two inches before reaching the end of the place mat, fold under the end of the binding so that it will match the length of the place mat and finish sewing. Repeat with the bottom binding.

13. Fold the binding to the back and hand sew with a hidden whipstitch. Repeat to make four place mats.

change it up

The central stem of the Floral Fiesta appliqué pattern was mirror-imaged to create a very traditional style block. Grouping four of these blocks together using bright pink and red fabric on the teal background makes a very colorful wall hanging.

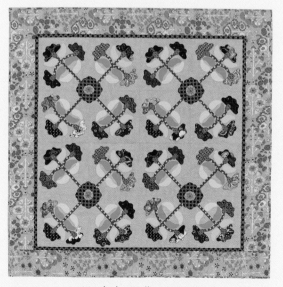

Made by Kelly Meanix
of Downingtown, Pennsylvania

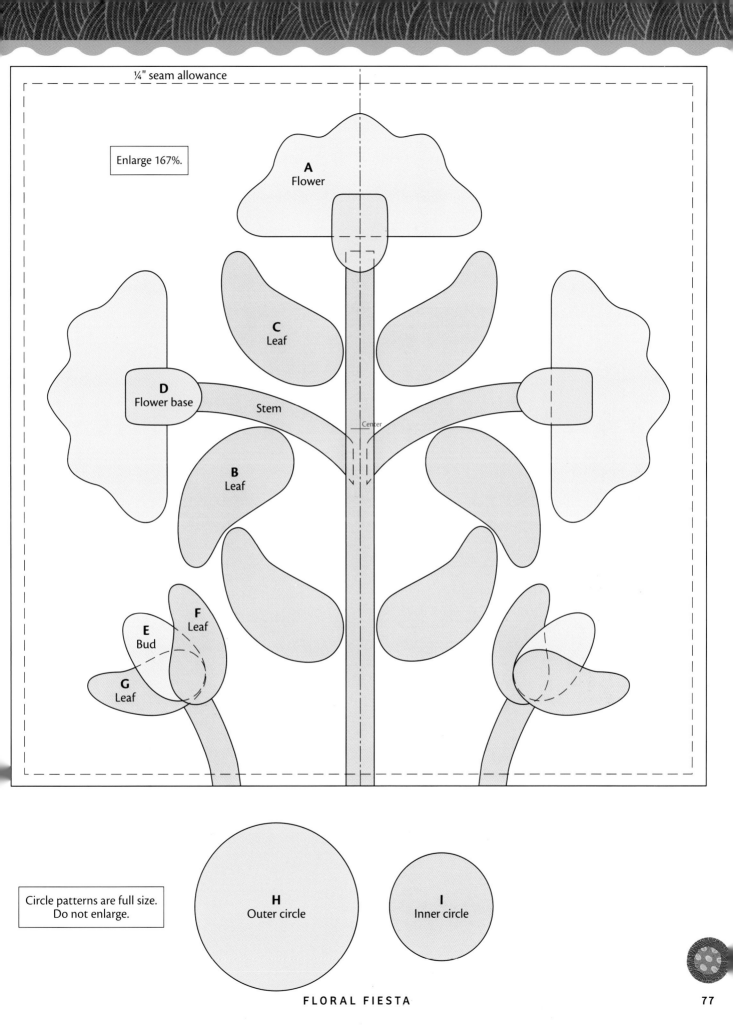

¼" seam allowance

Enlarge 167%.

A
Flower

C
Leaf

D
Flower base

Stem

Center

B
Leaf

E
Bud

F
Leaf

G
Leaf

Circle patterns are full size.
Do not enlarge.

H
Outer circle

I
Inner circle

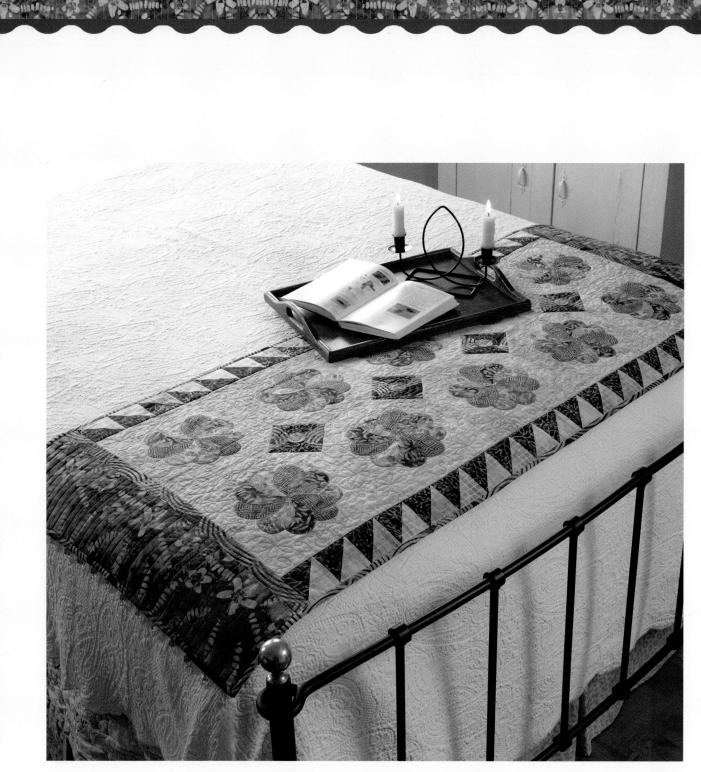

Finished quilt: 24½" x 60" • Finished blocks: 9½" x 9½"
Designed, made, and machine quilted by Cheryl Lynch

Pinwheel **Piñata**

Almost everyone at some time has witnessed the chaos and squeals of joy that result when blindfolded children swing at a piñata, trying to get to the candy and small prizes inside. The piñata has its roots in China. Marco Polo brought it to Europe and eventually the piñata made its way to Latin America, where it became part of religious rituals as a representation of Satan, disguised with a fancy mask. The smashing of the piñata represented the fight against evil and the candy inside was the reward.

MATERIALS

Yardage is based on 42"-wide fabric.

1¼ yards of light blue batik for background blocks and border triangles*

½ yard of lilac batik for end borders and pinwheel blades

⅝ yard of teal-and-purple batik for inner border, center diamonds, and binding

⅜ of indigo-and-purple batik for border triangles and center diamonds

Fat quarter (18" x 21") of blue geometric batik for pinwheel blades

Fat quarter (18" x 21") of chartreuse print batik for pinwheel blades and diamond circles

2 yards of backing

28" x 68" piece of batting

1⅜ yards of 17"-wide paper-backed fusible web

Parchment paper

32 light blue AB finish 8 mm square beads

32 clear 8 mm faceted round beads

32 size 6 chartreuse seed beads

Nymo thread for beading

Size 8 straw needle for beading

**If the fabric has less than 40" usable width after washing and putting on grain, you'll need 1½ yards.*

CUTTING

Cut all pieces across the width (crosswise grain) of the fabric unless otherwise noted. When the strip length is given as 42", simply cut from selvage to selvage across the full width of fabric.

From the light blue batik, cut:
3 strips, 10" x 42"; crosscut into 10 squares, 10" x 10"

2 strips, 3½" x 42"; crosscut into 19 squares, 3½" x 3½"

From the lilac batik, cut:
2 strips, 5½" x 24½"

From the indigo-and-purple batik, cut:
1 strip, 3" x 24"; crosscut into 8 squares, 3" x 3"

2 strips, 3½" x 42"; crosscut into 19 squares, 3½" x 3½"

From the teal-and-purple batik, cut:
1 strip, 3" x 24"; crosscut into 8 squares, 3" x 3"

2 strips, 1½" x 24½"

5 strips, 2¼ x 42"

APPLIQUÉ PIECES

Use the patterns on page 83 to create the appliqué pieces, referring to "Preparing the Appliqués" on page 15 as needed. The blade A pattern is reversed for fusible appliqué.

From the lilac batik, make:
30 of blade A

From the chartreuse print batik, make:
30 of blade A

4 of circle B

From the blue geometric batik, make:
30 of blade A

design decisions

This pinwheel tile intrigued me since the first time I saw it on the wall of the bathroom at our hotel. It reminds me very much of the Dresden Plate block. Using three analogous colors from the color wheel gives it a very calming effect. Choosing to make a bed runner, a long narrow quilt to place at the end of the bed, makes it a relatively quick decorative project. The beading adds a touch of elegance as well as weight to keep the edges down.

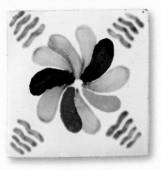

Inspiration tile

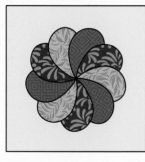

Quilt block

ASSEMBLING THE APPLIQUÉ BLOCKS

Refer to "Fusible Appliqué" on page 15 as needed.

1. Transfer the placement guide pattern on page 83 to a piece of parchment paper.

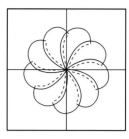

parchment paper

Parchment paper can be found in most supermarkets. Its intended use is for nonstick baking and cooking. Unlike wax paper, its silicone coating will not melt under an iron.

2. Choose three chartreuse, three blue geometric, and three lilac blade A pieces. Remove the paper backings. Position the first blade on the parchment paper at the 12 o'clock position, making sure it matches the placement guide. Press with a hot, dry iron. It should adhere to the paper.

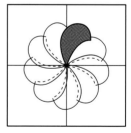

3. Going clockwise, position the next blade in place, overlapping the edge of the first blade. Press. Repeat, going clockwise with the next six blades, overlapping the previous blade. To position the ninth blade on the placement guide, lift up the left edge of the first blade and slide the right edge of the last blade underneath. Adjust the center where all of the blades meet so that it lies flat. Press.

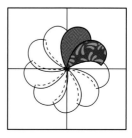 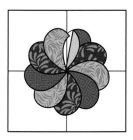

4. Peel the completed pinwheel from the parchment paper, marking the vertical and horizontal axis with straight pins.

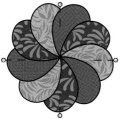

5. Fold a 10" light blue square in half vertically and press. Then fold in half horizontally and press again.

6. Line up the four straight pins in the pinwheel appliqué with the ironed lines of the background square. Remove the pins and fuse in place. Make 10 blocks. You can reuse the parchment paper for each block.

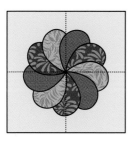

Make 10.

7. Stitch the appliqué with a blanket stitch along all of the edges. To limit the number of threads to tie off, stitch two blades at a time following the shape of the letter S as shown.

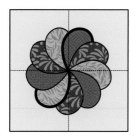

ASSEMBLING THE BED RUNNER

1. Using the illustration for fabric placement, add the triangles to the corners of the blocks by placing a 3" indigo-and-purple or a 3" teal-and-purple square in the appropriate corner of each block and stitching across the square on the diagonal. Press the resulting

triangle toward the corner. Lift the top triangle and trim the bottom two layers, leaving a ¼" seam allowance.

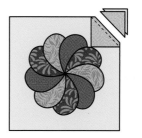

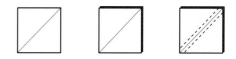

2. Sew the blocks together, pressing in opposite directions from row to row.

3. Fuse a circle B in the center of each of the four newly made diamonds. Blanket-stitch around the circles.

4. To prepare the 38 half-square-triangle units for the borders, mark a line diagonally on the wrong side of each of the 19 light blue batik 3½" squares. Place the indigo-and-purple 3½" squares right sides together with the 19 light blue squares. Stitch ¼" on either side of the diagonal line.

5. Cut on the diagonal line and press the seam allowances toward the darker triangle. Make a total of 38 half-square-triangle units. Trim to 3" x 3".

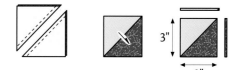

6. Create one pieced border strip with 19 half-square-triangle units, referring to the bed-runner layout diagram on page 82 for placement. Repeat for a second pieced border strip. Sew the pieced borders to the sides of the bed runner. Press the seam allowances toward the blocks.

7. Sew a 1½" x 24½" teal-and-purple strip to each end of the bed runner. Press.

8. Add a 5½" x 24½" lilac strip to each end of the bed runner. Press.

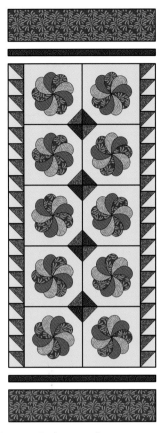

Bed runner layout

FINISHING THE BED RUNNER

Refer to "Quilt Construction" on page 20 for details if needed.

1. Prepare a 27" x 67" backing by either creatively piecing one or using the fabric listed in the materials list. If using the listed yardage, remove the selvages and cut it in half crosswise. Sew together along the long edges and press the seam allowance to one side. Trim the excess.

2. Prepare a label and sew it to the back of the runner.

3. Layer the runner top, batting, and backing; baste.

4. Decide on a quilting design and mark the runner if necessary. The runner shown on page 78 was machine quilted with an allover daisy pattern.

5. Bind with the 2¼" x 42" teal-and-purple strips.

BEADING THE BED RUNNER

1. Mark the placement for the beads 1½" apart with either a straight pin or washable marker.

2. Thread the needle with Nymo beading thread. Enter the back of the bed runner and exit through the edge of the binding, popping the knot in toward the batting if possible. Take a backstitch.

3. Place one of each different bead on the needle and thread back through all of the beads except for the chartreuse one on the end. Enter the binding as close as possible to where you came out and travel to the next location. Take a backstitch.

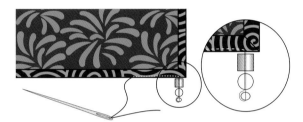

4. Repeat step 3 until the beading is done. Take a backstitch. Tie a knot, bury it in the fabric, and then make a few more stitches, hiding them in the edge of the binding.

change it up

Nine Pinwheel Piñata blocks were pieced together to create this wall hanging. Using red pinwheels on a white background makes a vibrant statement.

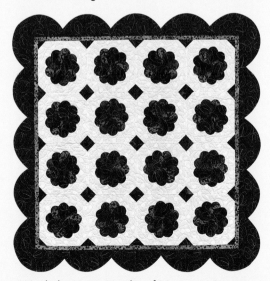

Made by Hattie Virgilio of Newtown Square, Pennsylvania; quilted by Susie Racobaldo

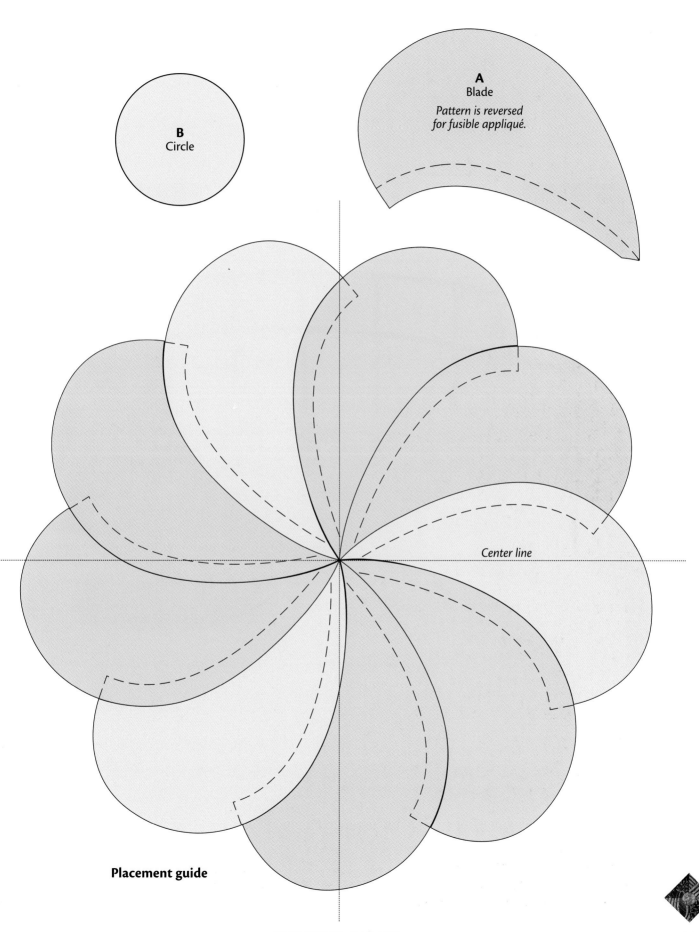

B
Circle

A
Blade
Pattern is reversed for fusible appliqué.

Center line

Placement guide

Finished pillowcase top: 55½" x 19" • Finished blocks: 9½" x 9½"
Designed and made by Cheryl Lynch

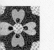

Roja

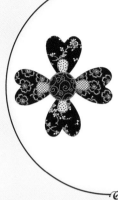

Years ago there was a river that ran through the city of Puebla. On wash day, the women would come down to the river carrying chalupitas (baskets) filled with their dirty clothes. After spending the day doing laundry, it was still expected that there be a hot meal on the dinner table. So, the women devised a dish that was quick and easy to make. It was named after their baskets. Thus chalupas were born—shredded pork and onions on a pan-fried tortilla, served with a salsa roja (red) or a salsa verde (green). It's the Poblano equivalent of fast food. So the story goes.

MATERIALS

Yardage is based on 42"-wide fabric.

1¼ yards of white-and-red grid print for outer petals, inner petals, prairie points, and pillow back

⅞ yard of red swirl print for block backgrounds, corners, circles, and outer borders

⅔ yard of small-scale white floral for block backgrounds, corners, circles, and prairie points

⅓ yard of white-and-red dot print for inner petals, outer petals, inner borders, and prairie points

Fat eighth (9" x 21") of red-and-white vine print for inner petals and outer petals

Fat eighth (9" x 21") of red-with-blue floral for inner petals and outer petals

2 yards of 17"-wide paper-backed fusible web

1 body pillow, 20" x 54"

CUTTING

Cut all pieces across the width (crosswise grain) of the fabric unless otherwise noted. When the strip length is given as 42", simply cut from selvage to selvage across the full width of fabric.

From the red swirl print, cut:
5 squares, 10" x 10"

2 strips, 2¼" x 38½"

From the small-scale white floral, cut:
5 squares, 10" x 10"

4 squares, 4" x 4"

From the white-and-red dot print, cut:
2 strips, 1" x 38½"

4 squares, 4" x 4"

From the white-and-red grid print, cut:
1 rectangle, 18" x 19½"

1 rectangle, 19½" x 35"

6 squares, 4" x 4"

APPLIQUÉ PIECES

Use the patterns on page 89 to create the appliqué pieces, referring to "Preparing the Appliqués" on page 15 as needed.

From the white-and-red dot print, make:
10 of inner petal A

10 of outer petal B

From the white-and-red grid print, make:
10 of inner petal A

10 of outer petal B

From the red-and-white vine print, make:
10 of inner petal A

10 of outer petal B

From the red-with-blue floral, make:
10 of inner petal A

10 of outer petal B

From the red swirl print, make:
5 of circle C

20 of corner D

From the small-scale white floral, make:
5 of circle C

20 of corner D

design decisions

The original coloring of this tile was cream and yellow on a blue background. Changing it to a two-color quilt pattern focuses on the positive/negative design. Repeating this concept for the background blocks makes a project with a high amount of contrast.

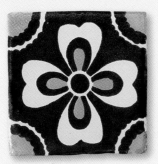

Inspiration tile

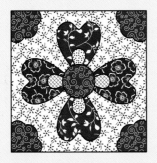

Quilt block

ASSEMBLING THE BLOCKS

Refer to "Fusible Appliqué" on page 15 as needed.

1. Remove the paper backing from only the inner petal A pieces. Place each inner petal at the base of a contrasting outer petal B. You will have 20 red inner petals with white outer petals and 20 white inner petals with red outer petals. Fuse the inner petals in place. Remove the paper backing from the outer petals and blanket-stitch around the inner petals.

Make 20. Make 20.

2. Arrange four petal units on a contrasting 10" background square using the pattern on page 89 for placement. I placed matching large petals opposite each other. Fuse in place and blanket-stitch around each outer petal. Fuse a contrasting corner D to each corner and blanket-stitch. Repeat to make five blocks with each background fabric, totaling 10 blocks.

3. Place, fuse, and appliqué the appropriate circle C in the center of each block.

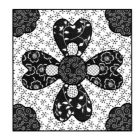 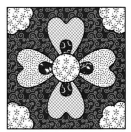

Make 5. Make 5.

PILLOW ASSEMBLY

1. Sew the blocks together, alternating the background colors.

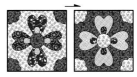
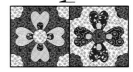
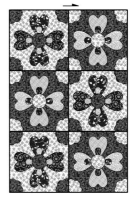

2. To prepare the pillowcase back, one edge of each of the two white-and-red grid backing pieces must be finished. For each backing piece, fold under ¼" to the wrong side on a 19½" edge. Press. Then fold under again ½". Stitch the fold close to the edge.

3. Lay the two backing pieces on a table, right sides up. Overlap them with the longer piece underneath so that they measure 48" from edge to edge. Pin to stabilize. Keep these pins in place until after step 8.

4. Stitch the back to the pillowcase top, right sides together, along one long edge. Press.

5. Sew each of the white border strips to a red border strip. Press toward the red. Attach each of these border strips to the sides of the pillow. Press.

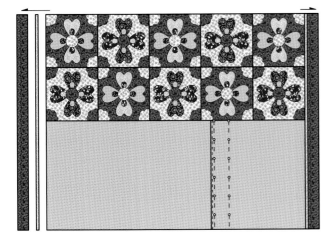

6. To prepare the 14 prairie points, first fold a 4" square in half diagonally, wrong sides together. Press. I recommend using steam when pressing to achieve very flat pieces. Fold in half again, point to point, and press.

Make 14.

7. Find and mark the middle of each of the side borders of the pillowcase. Spread out seven prairie points ½" from this point to ½" from the edge of the pillowcase's front, right side up and raw edges aligned. Tuck the points into each other and pin in place. Machine-baste a scant ¼" from the edge.

8. Fold the pillowcase's back to the front, right sides together. Stitch the remaining three sides.

9. Turn the pillowcase right side out through the opening in the back and press. Topstitch ⅛" from the prairie points.

10. Insert body pillow.

pillow insertion

Leave the body pillow in its plastic bag. It will slip into the pillowcase much more easily. Wiggle the plastic bag out to remove it.

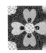

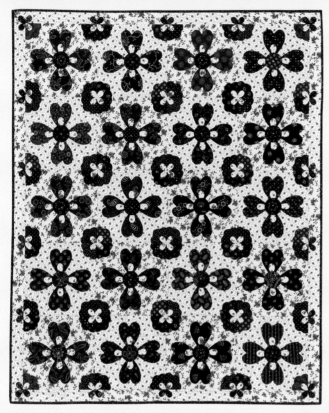

The Roja block can be used to make a wall hanging or a quilt. This blue-and-white quilt is a direct interpretation of the two-color scheme. Rolinda added inner petals to the corner pieces to create a nice balance of dark and light.

Made by Rolinda Brackbill
of New Holland, Pennsylvania

This chartreuse-and-blue quilt uses the same blocks as Roja. The striped fabric gives it whimsy and the prairie points are sewn into the borders and held down with buttons.

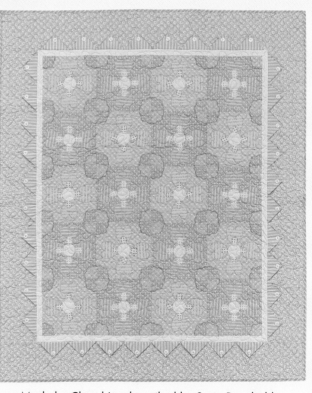

Made by Cheryl Lynch; quilted by Susie Racobaldo

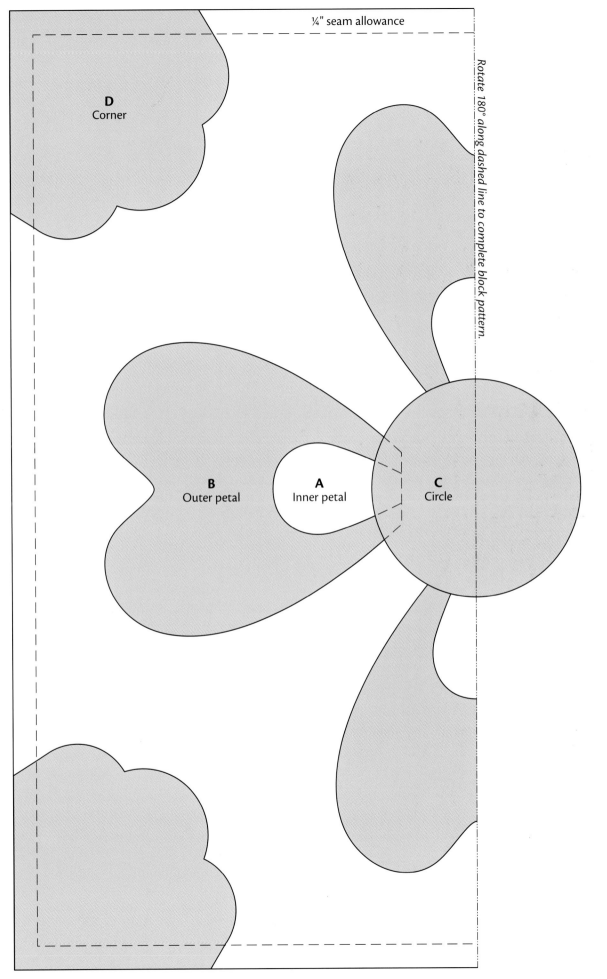

¼" seam allowance

D
Corner

B
Outer petal

A
Inner petal

C
Circle

Rotate 180° along dashed line to complete block pattern.

From **Inspiration** to **Design**

So you've made one of the projects in the book or are thinking about making one. Maybe you like part of one and part of another. Or maybe you want to design one from scratch. The steps that would be used to turn a Talavera tile into a quilt can also be used to turn any design inspiration into a quilt.

There may be times when you see a photo, a flower, a building detail, a greeting card, or a fabric and you think, that would make a great quilt. The question then becomes, how to get from there to a quilt design? Freehand drawing doesn't work for everyone. There are options available to take your idea from inspiration to design.

CHOOSING THE DESIGN ELEMENTS

The first step is to be able to transfer your design to paper. You can use a photo, clip art, or anything that you can trace. Part of the process of designing is also learning what is superfluous to the design and what is essential.

Using a Talavera tile as a design inspiration, I traced the chosen parts of the design onto a clear piece of plastic or vinyl with a permanent marker. Design elements may be eliminated to simplify the block or added to balance it.

Then it's time to decide the finished size of the block or finished piece, if it's a one-block quilt.

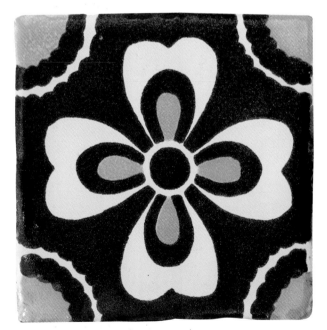

Inspiration tile

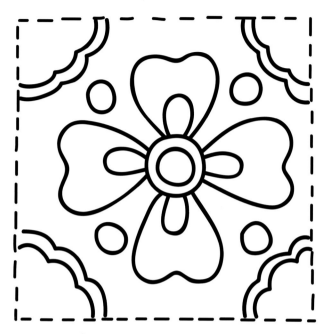

Early version of "Roja" block (page 85)

The two quickest and easiest tools for enlarging the traced design are the photocopy machine at your local copy center and an overhead projector. Not everyone has access to an overhead projector, but it's wonderful to have if you want to enlarge your design to larger than 11" x 17". A dark room, a blank wall, paper taped to the wall, and a pencil are all that you need.

An alternative is to go to the local copy center. For designs less than 17", the enlarging feature on the self-serve machine is fine. If you know what finished size you want and the initial measurement, you can calculate the percentage to enlarge. Divide the desired larger size by the actual size of your design. Multiply by 100. For example, if the original design is 6" and you want to enlarge it so the finished pattern is 9":

$9 \div 6 = 1.5 \times 100 = 150\%$

It will need to be enlarged by 150%.

The largest paper size that is usually available from a self-serve machine is 11" x 17", but you can photocopy your design in sections and tape it together. If a very large size is needed (even as large as 36" x 48"), the copy center can do that too, for a pretty reasonable price.

DESIGNING A MEXICAN TILE QUILT

All the projects in this book, except the place mats, have blocks that are 9½" finished. This means that all of the block elements or all of the blocks can be mixed and matched to create a unique pattern.

In addition to the patterns, on pages 92 and 93 you'll find a library of center and corner designs that can be combined into a quilt. Pick and choose and play around. Enlarge them. Combine corner and center designs. Color them with colored pencils and choose what works for you. Mix and match to your heart's content and see what you can discover and create. Enjoy the process.

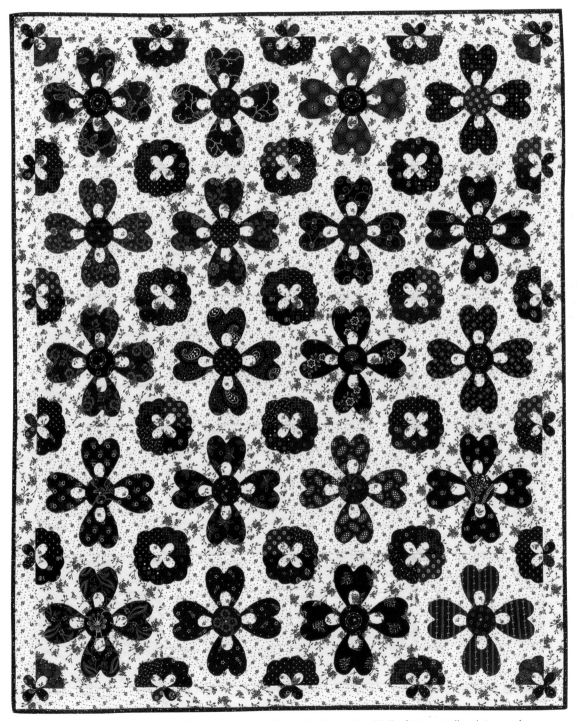

Instead of alternating dark and light blocks like "Roja," Rolinda Brackbill of New Holland, Pennsylvania, made all her blocks with dark outer petals and corners appliquéd on light print backgrounds.

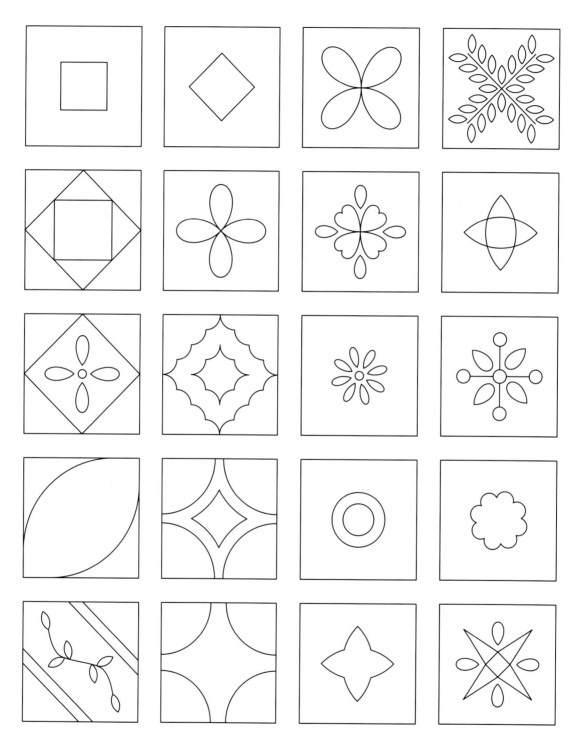

Center design options

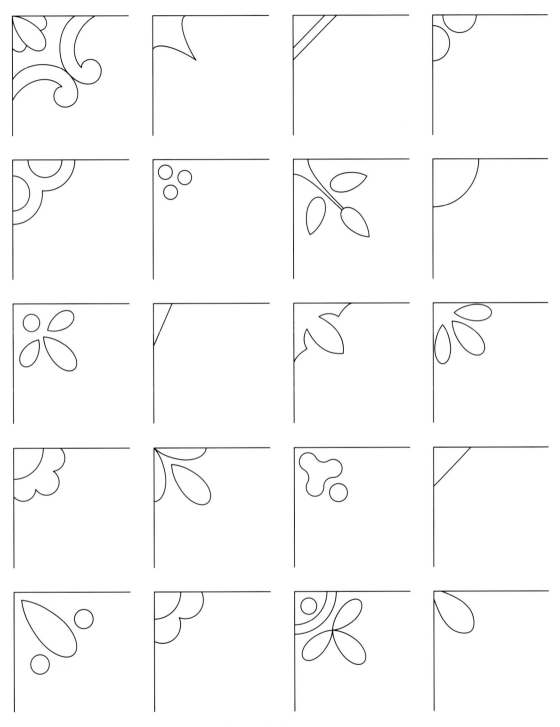

Corner design options

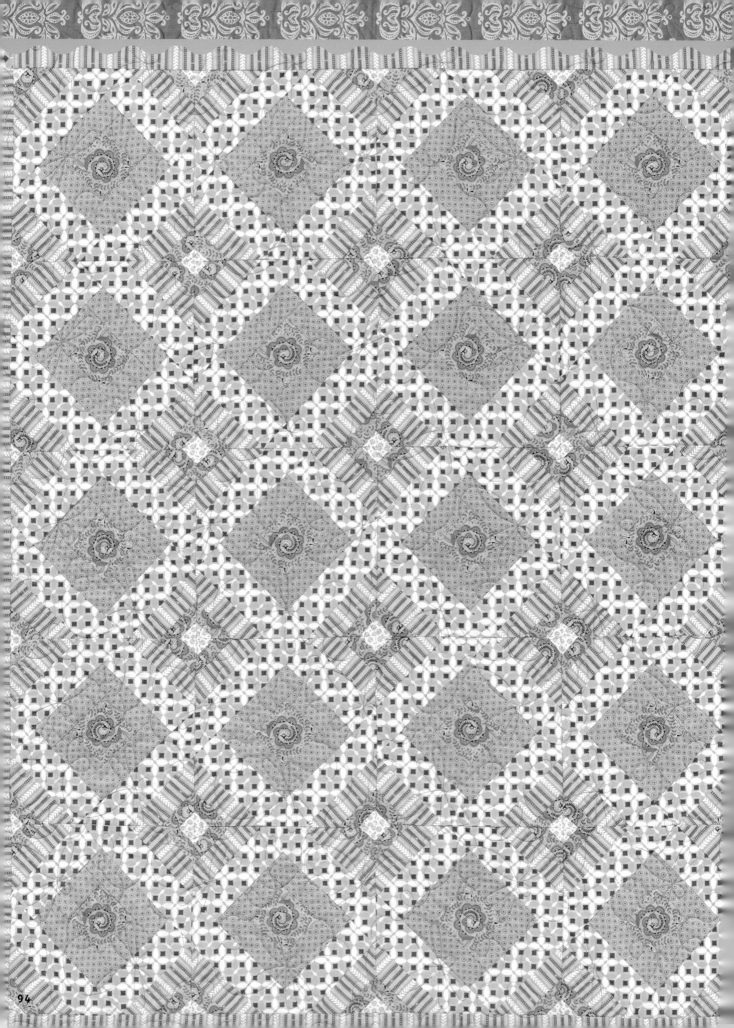

94

About the Author

Cheryl Lynch made her first quilt out of Marimekko fabric as an impoverished chemistry graduate student at the Massachusetts Institute of Technology. It took another 17 years for her to make her second quilt—after a corporate career and some child rearing.

When she moved to Pennsylvania in 1992, both her sons were in school and she started taking some basic quilting classes. It was something that Cheryl had always wanted to do. It didn't take long before she fell in love with everything about quilting and started to design her own quilts. Cheryl then started teaching at a local quilt shop and published her own pattern line.

Fascinated by the color and texture of fabric, Cheryl discovered that she could create art and folk art without knowing how to paint with a brush. The challenge became how to turn her ideas into quilts. That's where her technical background came in handy.

Cheryl's quilts have been published in national quilt magazines, won ribbons in quilt shows, and have been displayed in quilt exhibitions and museums. A particular honor was the inclusion of one of her quilts, "Leaving Us," in the national traveling exhibit "Alzheimer's: Forgetting Piece by Piece."

Cheryl still lives outside of Philadelphia with her husband and their dog, Bailey. When she's not quilting, you can find her on the highways and byways riding her bike.

there's more online!

To see more of Cheryl's work, visit her website at www.cheryllynchquilts.com or her blog at www.cheryllynchquilts.blogspot.com. Find more books about quilting at www.martingale-pub.com.

You might also enjoy these other fine titles from
Martingale & Company

Our books are available at bookstores and your favorite craft, fabric, and yarn retailers.
Visit us at www.martingale-pub.com or contact us at:

1-800-426-3126

International: 1-425-483-3313
Fax: 1-425-486-7596
Email: info@martingale-pub.com

Martingale®
& COMPANY

America's Best-Loved Craft & Hobby Books®
America's Best-Loved Knitting Books®

That Patchwork Place®

America's Best-Loved Quilt Books®